DRAWING CLASS:

ANIMALS

Learn to Draw with Simple Shapes and Online Tutorials

Access video tutorials for 60 animals via QR codes!

HEEGYUM KIM

QUARRY

CONTENTS

INTRODUCTION

I have always loved to draw.

I started out drawing foods and objects, but learning to draw animals felt like a big challenge to me.

I slowly started exploring animals by drawing a fox, a dog, a bear, and some others, and as I drew, I discovered that what was most fun was developing each animal's personality and unique shapes. I was attracted by how the simple geometric shapes created interesting forms.

I continued drawing animals, and though I felt that I had drawn many of them, I realized there are so many animals on this planet that there will always be new ones I haven't drawn! The best way to understand the physical characteristics of an animal is to start out with geometric shapes. I start with a large shape then gradually add details with smaller shapes and combine them to make a unique animal figure.

In this book, you'll find step-by-step lessons for drawing sixty animals using basic shapes. By drawing and combining simple rectangles, triangles, and circles, you'll easily be able to complete a figure. Then you can add details for the face, body, textures, patterns, and so on. You'll find a video tutorial of the step-by-step drawing by scanning the QR code on the right-hand page of each lesson. Once you've mastered an animal's basic form through the step-by-step lesson, use the full-color examples on the right-hand page for further inspiration, and experiment with different poses, facial expressions, or maybe just with some different accessories.

Set up a regular practice or find time when you can. It's always a good idea to challenge yourself to draw for 30 days or another prearranged period of time.

I hope this book provides you with loads of fun ways to expand your drawing skills and your imagination!

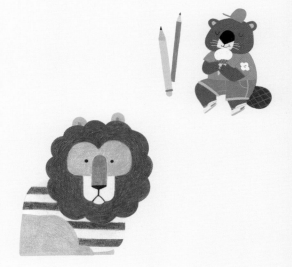

CAT

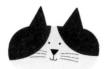

① Draw a small oval for the head.

② Below that, draw a rectangle for the body, overlapping with the head.

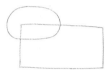

③ Draw two triangles on top of the head for the ears and round the corners of the body.

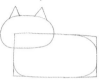

④ Remove all overlapping pencil lines.

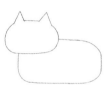

⑤ Draw a letter *S* shape for the tail. Run back. Draw a spot inside of the face.

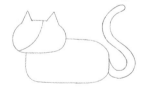

⑥ Add the eyes, nose, mouth, and details to the ears.

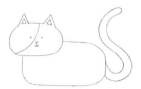

⑦ Draw a bandana and one hind leg and two front legs.

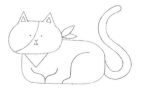

⑧ Add another spot on the body, whiskers, details on the front paws, and a toy.

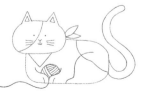

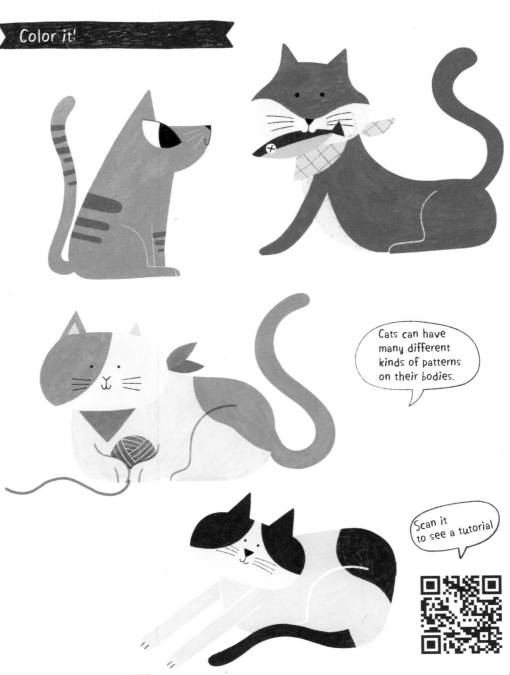

Color it!

Cats can have
many different
kinds of patterns
on their bodies.

Scan it
to see a tutorial

DOG

1. Draw a rectangle for the body.

2. Draw a smaller rectangle on one side on the top for the head and four long rectangles below the body for the legs and paws.

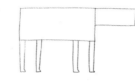

3. Draw an elongated half-circle for an ear.

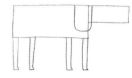

4. Round all the corners.

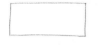

5. Draw a curved tail and add the eyes, mouth, and nose.

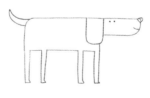

6. Draw spots on the body. Fill in the nose in with black and add other details.

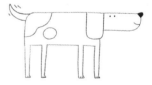

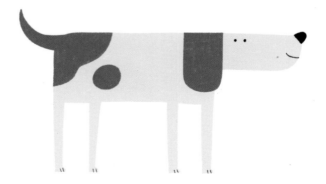

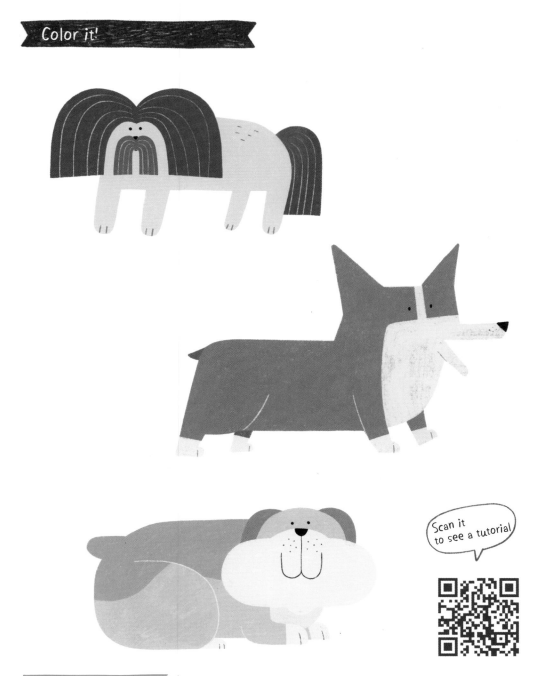

Color it!

Scan it to see a tutorial

HORSE

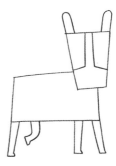

1 Draw a long and narrow rectangle for the face.

2 Below that, draw another rectangle for the body. Draw two elongated half-circles on the top of the head for the ears.

3 Draw four long rectangles for the legs, making one of the back legs curved. Add marks on the face.

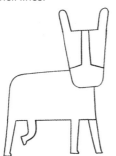

4 Round the hindquarters and remove all overlapping pencil lines.

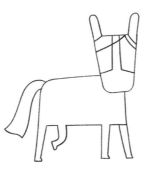

5 Add hairs on the head and a long tail.

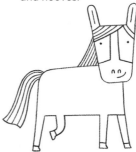

6 Draw lines for the hair on the head, mane, and tail. Draw the eyes, nostrils, and mouth. Add details to the ears and hooves.

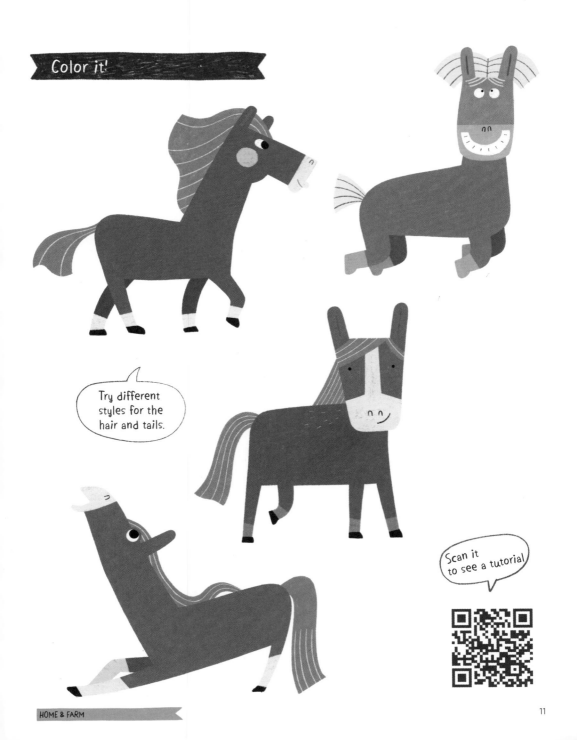

Color it!

Try different styles for the hair and tails.

Scan it to see a tutorial

GUINEA PIG

1 Draw a circle for the head.

2 For the body, draw a large oval attached to the head.

3 Draw a wavy vertical line down through the head for the muzzle and a half-circle on top for an ear.

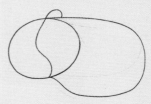

4 Remove all overlapping pencil lines.

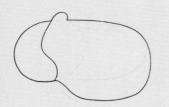

5 Draw the eye, nostril, mouth, and some speckles on the muzzle. Add the two hind legs and paws.

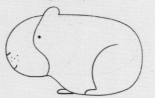

6 Add the whiskers, detail on the ear, and two more vertical wavy lines on the body.

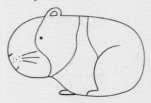

Drawing Class: Animals

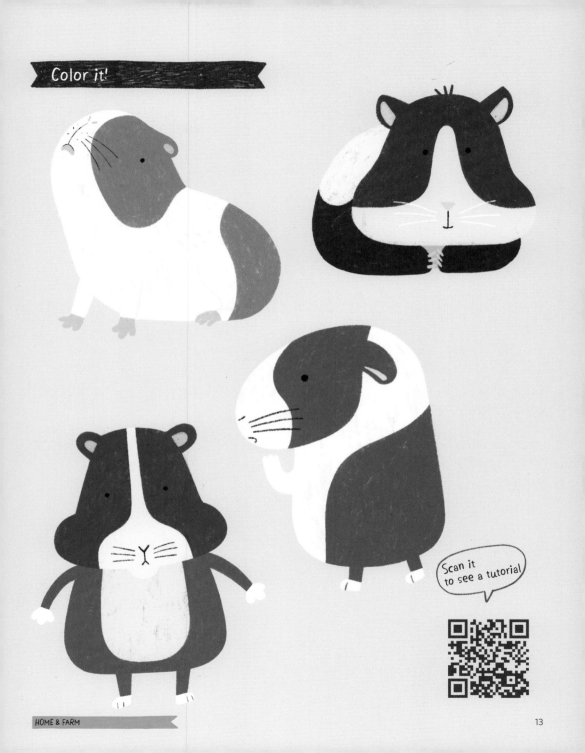

Color it!

Scan it to see a tutorial

GOOSE

1 Draw a slightly curved long, narrow rectangle for the neck.

2 Below that, draw a hexagon for the body.

3 Draw a small uneven rectangle on the side of the neck at the top and add two legs and feet.

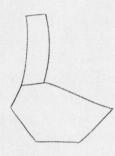

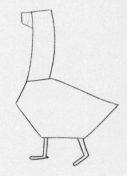

4 Round the corners of the head and chest.

5 Remove all overlapping pencil lines.

6 Draw a beak, an eye, and a wing.

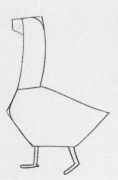

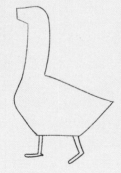

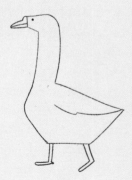

Drawing Class: Animals

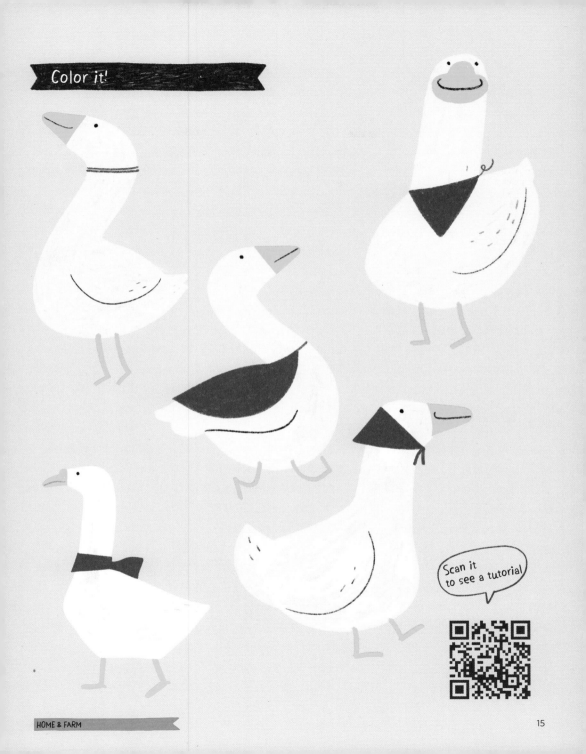

Color it!

Scan it
to see a tutorial

PIG

1 Draw a circle for the head.

2 For the body, draw a rectangle attached to the head.

3 Round the hindquarters. Draw four small squares for the legs.

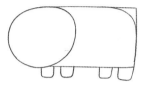

4 Remove all overlapping pencil lines.

5 Draw an oval for the nose and two small triangles for the ears.

6 Draw the nostrils, eyes, mouth, and tail and add other details.

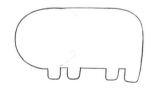

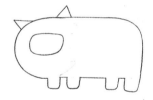

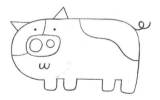

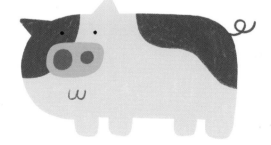

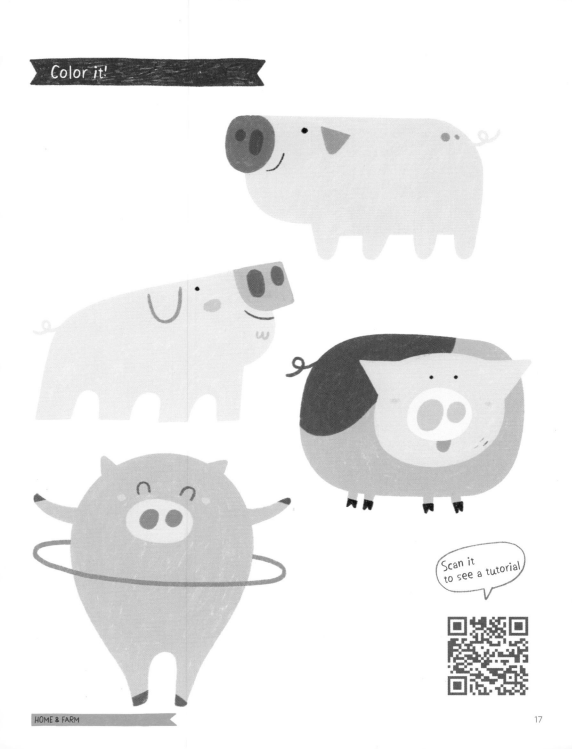

Scan it
to see a tutorial

SHEEP

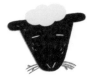

① Draw an upside-down triangle for the head, making the bottom of it round.

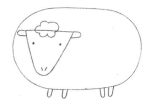

② For the body, draw a big oval around the head.

③ Draw an elongated half-circle on each side of head for the ears and small cloud on top for a tuft of hair.

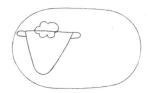

④ Draw two eyes and nostrils. Draw four small elongated half-circles for the legs.

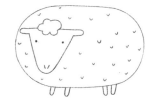

⑤ Remove all overlapping pencil lines. Draw small squiggles to add texture on the body.

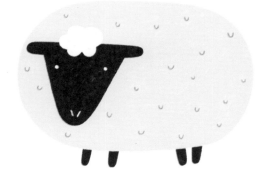

Drawing Class: Animals

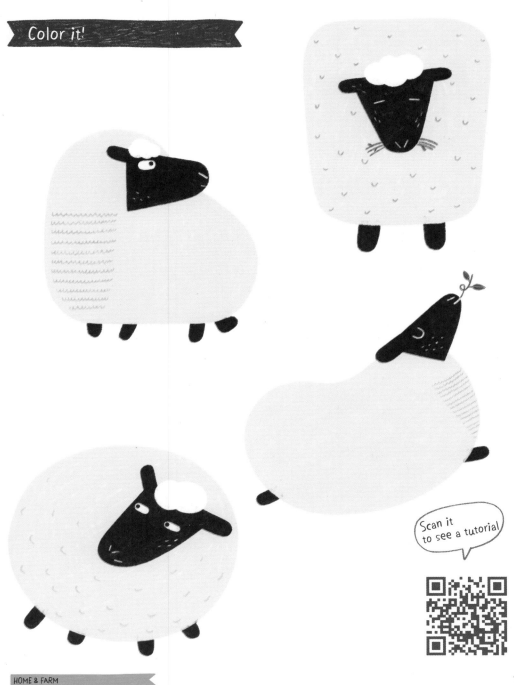

Scan it to see a tutorial

ELEPHANT

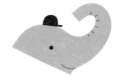

1 Draw a big, rounded rectangle for the body.

2 Draw a letter *U* shape for the trunk.

3 Draw two half-circles for the legs.

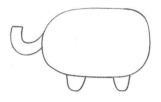

4 Draw a fan shape for the ear.

5 Remove all overlapping pencil lines.

6 Draw the eye and a tail. Add some wrinkles on the nose and marks for hair on the legs and body.

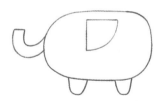

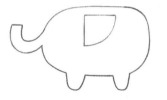

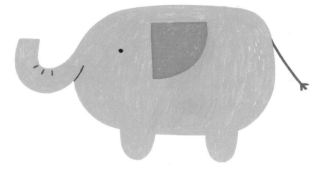

Drawing Class: Animals

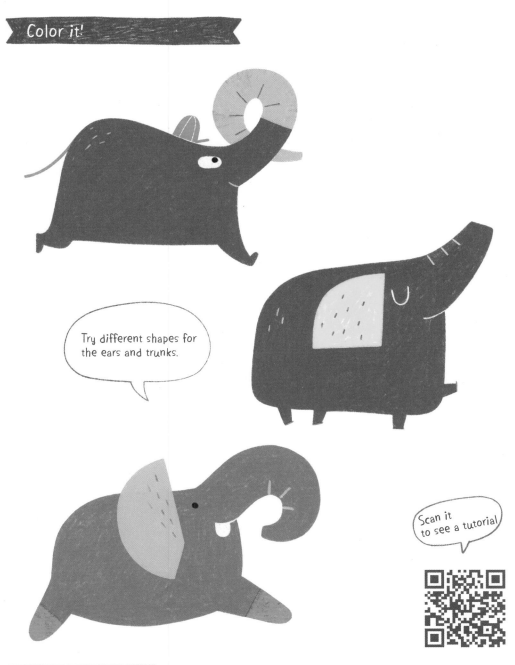

Try different shapes for the ears and trunks.

Scan it to see a tutorial

LION

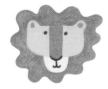

1 Draw a circle for the head.

2 Draw a small rectangle inside the head and add a small square below it for the face.

3 For the body, draw a rectangle on one side of the head. Round the corners of the face and add two half-circles on top for the ears.

4 Round the corners of the body and add the front and back legs and paws.

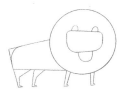

5 Remove all overlapping pencil lines. Draw the eyes, nose, and mouth and add a tail.

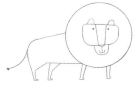

6 Add a mane of little triangles along the inner edge of the circle.

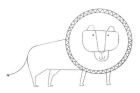

7 Remove the pencil lines from the outer edge of the mane.

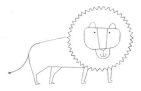

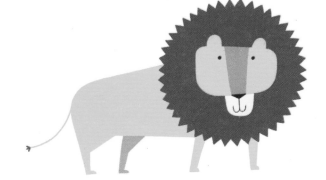

Drawing Class: Animals

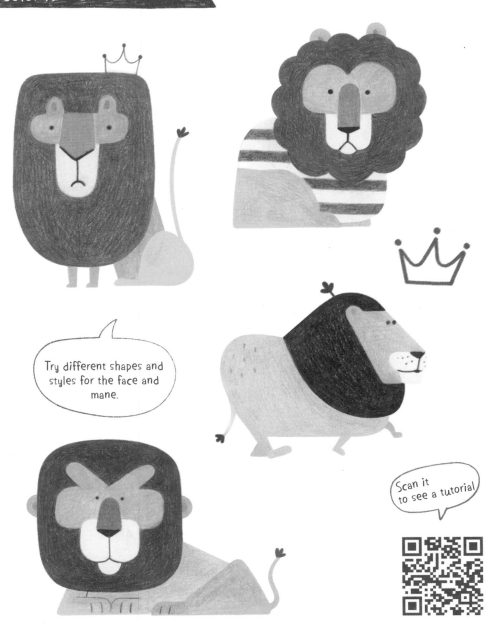

Try different shapes and styles for the face and mane.

Scan it to see a tutorial

ZEBRA

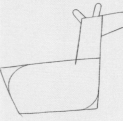

1 Draw a large rectangle for the body.

2 Draw a smaller rectangle on top of one side of the body for the neck and attach a small uneven rectangle for the snout.

3 Round the corners of the body and snout. Draw two elongated half-circles for the ears.

4 Remove all overlapping pencil lines.

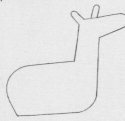

5 Draw a line on the snout, a mouth, and four legs with hooves.

6 Draw more elongated half-circles for stripes on the neck and add a tail. Draw two eyes.

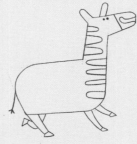

7 Add vertical lines for stripes on the body and hair on the head and neck.

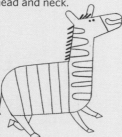

8 Add more stripes on the legs.

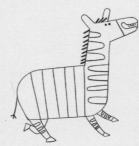

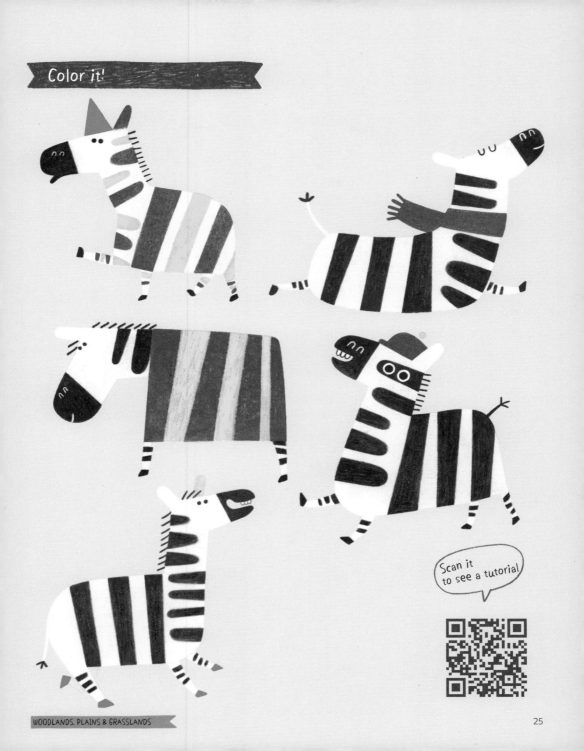

Color it!

Scan it
to see a tutorial

RHINO

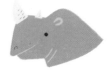

1. Draw a square for the head.

2. For the body, draw a pentagon attached to the head.

3. Inside the head, draw the face. Round the pointy hindquarters and draw two small squares for the legs.

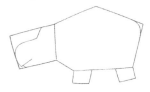

4. Remove all overlapping pencil lines.

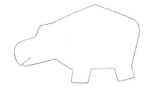

5. Draw a large crescent shape for a horn. Add another small horn, an eye, nostril, and an elongated half-circle for the ear.

6. Draw a tail and add some wrinkles around the neck. Add details to the toes and body.

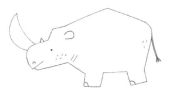

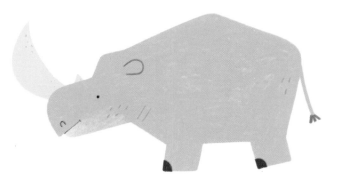

Drawing Class: Animals

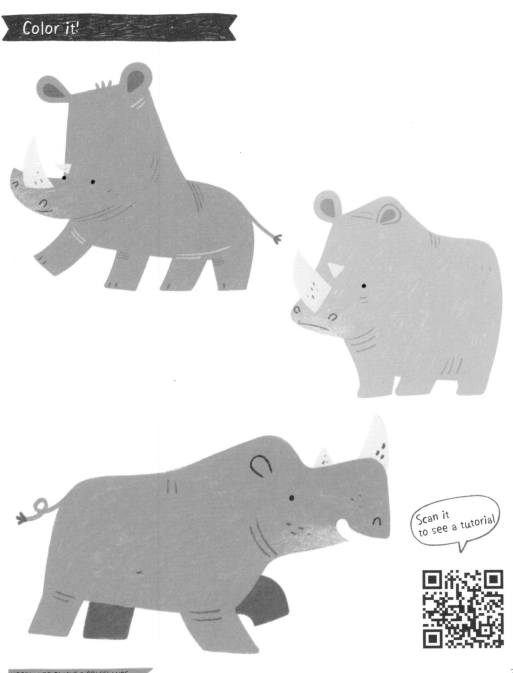

Scan it to see a tutorial

FENNEC FOX

❶ Draw a rectangle for the head.

❷ Inside the rectangle, draw a rounded trapezoid for the face. Draw a small half-circle below the face.

❸ Draw two big triangular ears and a small, rounded triangle on top of the half-circle for the snout.

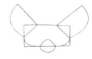

❹ For the body, draw a solid letter *P* shape attached to the head.

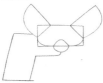

❺ Draw one hind leg and two front legs with paws.

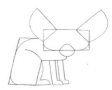

❻ Round the corners of the body.

❼ Remove all overlapping pencil lines.

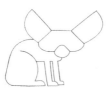

❽ Draw a big tail, two eyes, and a nose and details in the ears.

❾ Draw the whiskers and add details to the paws.

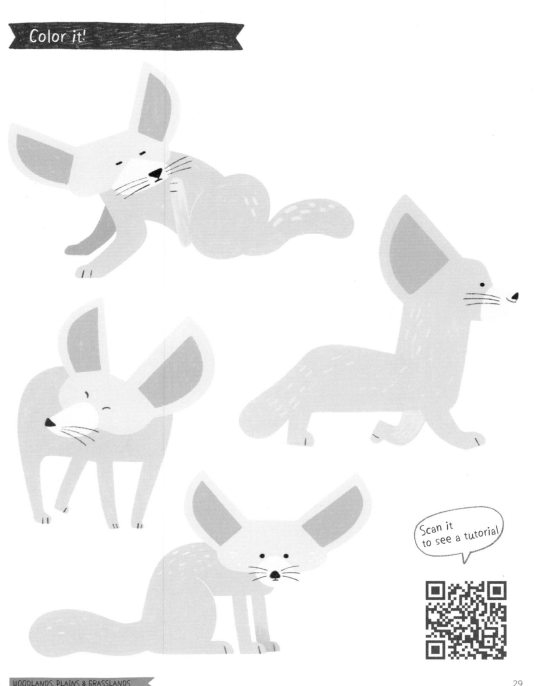

Scan it
to see a tutorial

HEDGEHOG

① Draw a rectangle for the body.

② Draw a small square on one side of the body on the bottom for the face.

③ Draw a little pointy nose sticking out of the face.

④ Round the corner of the head and add a horizontal guideline at the top of the body for the spikes.

⑤ Draw zigzags for the spikes.

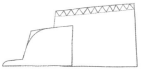

⑥ Remove all overlapping pencil lines.

⑦ Draw the eyes, nose, and mouth and add a mark to the face. Draw four short legs.

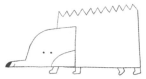

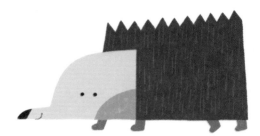

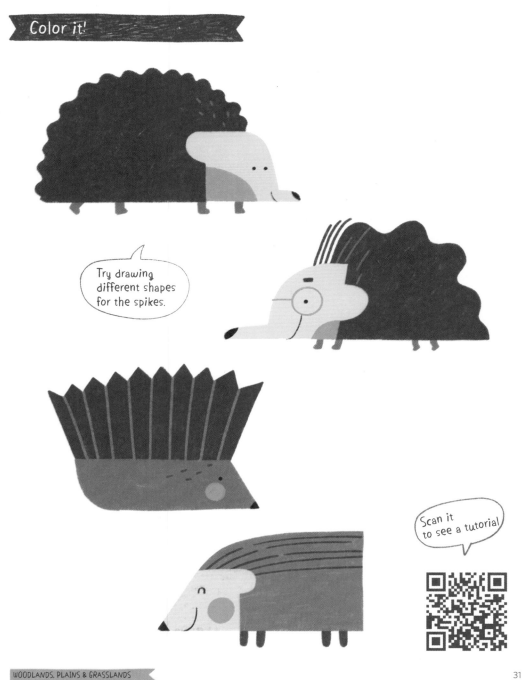

WILD BOAR

1 Draw a rectangle for the body.

2 For the head, draw a trapezoid on one side of the body attached to the bottom.

3 Round the corners of the body.

4 Draw a half-circle for the nose.

5 Remove all overlapping pencil lines. Draw the ears, eyes, and four small elongated half-circles for the legs.

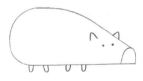

6 Draw a mouth, a tooth, and two nostrils.

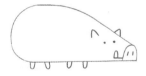

7 Draw spiny shapes on the back for the bristly hair. Draw a straight tail.

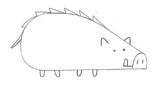

8 Remove all overlapping pencil lines.

9 Add hairs on the body and tail.

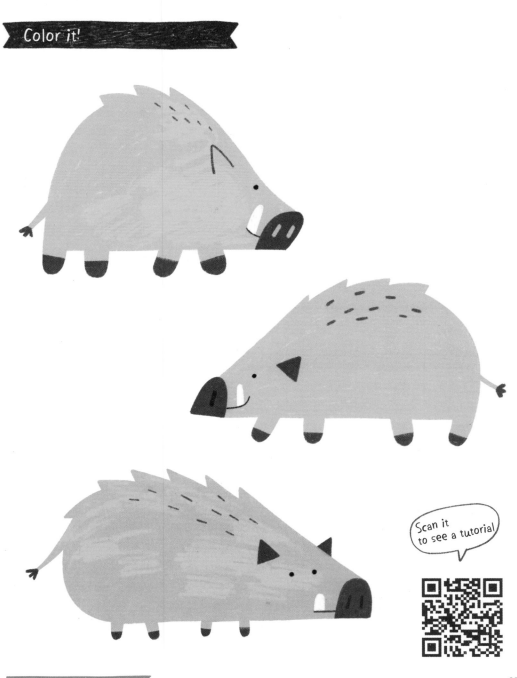

Scan it to see a tutorial

BADGER

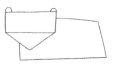

1 Draw a rectangle for the head.

2 Below that, draw a triangle for the snout. To the top of the head, add two half-circles for the ears.

3 For the body, draw a rectangle attached to the head.

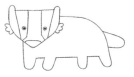

4 Round the corners of the head and the body and add four elongated half-circles for the legs.

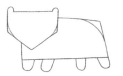

5 Remove all overlapping pencil lines. Draw the nose.

6 Draw the eyes and add a tail. Add marks around the eyes and a tufts of fur on both sides of the head.

7 Fill in the eye marks and nose with black.

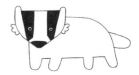

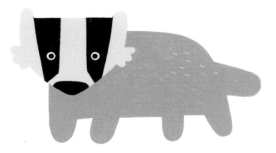

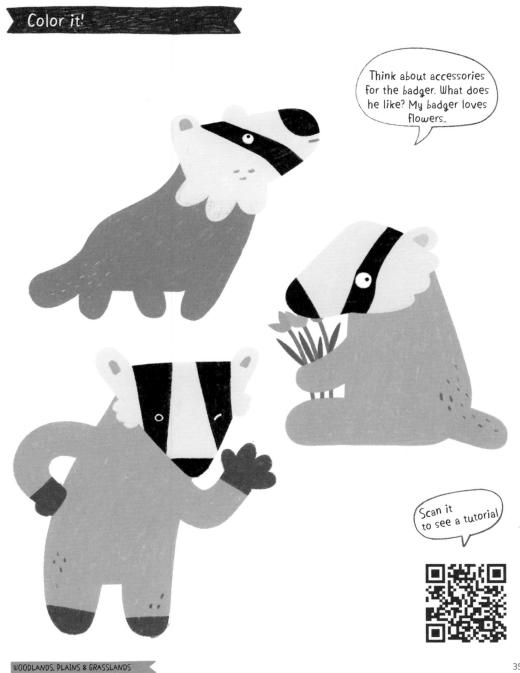

Think about accessories for the badger. What does he like? My badger loves flowers..

Scan it to see a tutorial

BROWN BEAR

1 Draw a large rectangle for the body.

2 Draw a smaller rectangle attached to the top of one side for the head and draw a curved line connecting the head to the body.

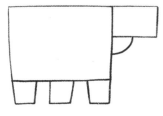

3 Draw three rectangles below the body for the legs. It doesn't always need to be four!

4 Round the hindquarter.

Let's make the hindquarters round!

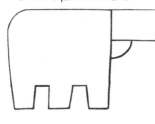

5 Draw two half-circles on the head for the ears and an open mouth. Remove all overlapping pencil lines.

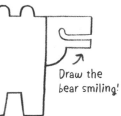

Draw the bear smiling!

6 Draw the two eyes and a nose. Add details to the body and snout.

Make a little triangle in the corner for the nose.

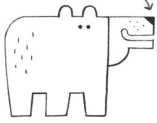

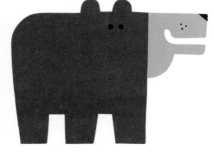

Drawing Class: Animals

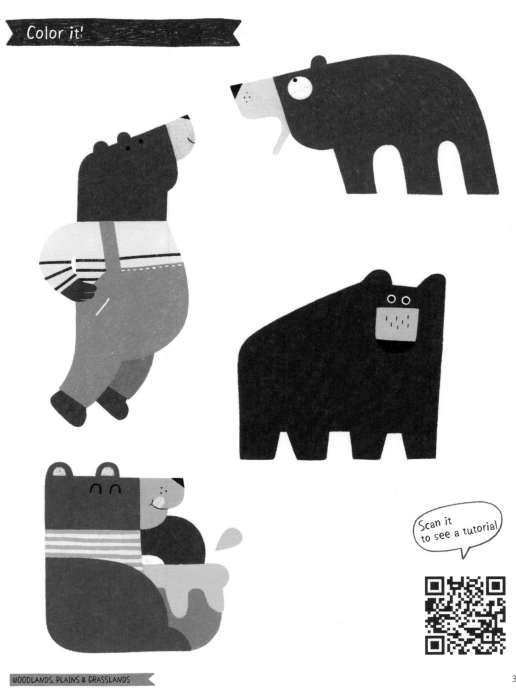

Scan it to see a tutorial

PANDA

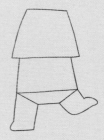

❶ Draw a trapezoid for the head.

❷ Below that, draw a square for the body and then add another trapezoid beneath it.

❸ Draw two short legs.

❹ Round the corners of the head. Add two rectangles for the eye patches and a triangle for the nose.

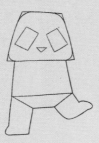

❺ Draw two arms.

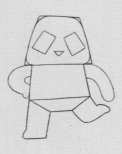

❻ Add the eyes and a mouth and fill in the ears, eye patches, and nose with black. Draw a stalk of bamboo in one paw.

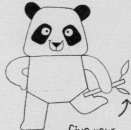

Give your panda a stalk of bamboo to hold.

❼ Fill in the arms and legs with black.

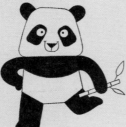

Drawing Class: Animals

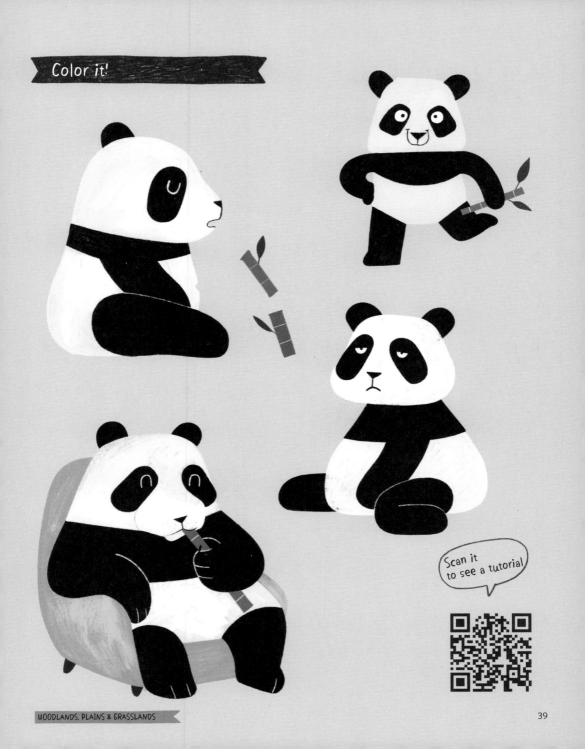

Color it!

Scan it
to see a tutorial

SQUIRREL

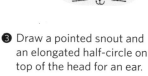

① Draw a square for the head.

② Draw a rectangle connected to the head for the neck and add another rectangle below the neck for the body.

③ Draw a pointed snout and an elongated half-circle on top of the head for an ear.

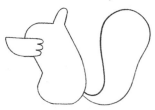

④ Round all the corners.

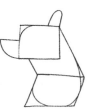

⑤ Remove all overlapping pencil lines.

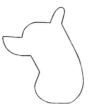

⑥ Draw some fur on the snout and a bushy tail.

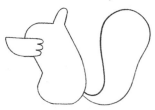

⑦ Draw the eyes, nose, and mouth. Add a hind leg and foot and a line down the body for the stomach.

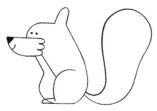

⑧ Draw a front leg with a paw holding an acorn.

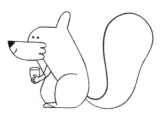

⑨ Draw whiskers, some hairs on top of the ear, and detail on the tail.

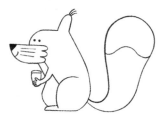

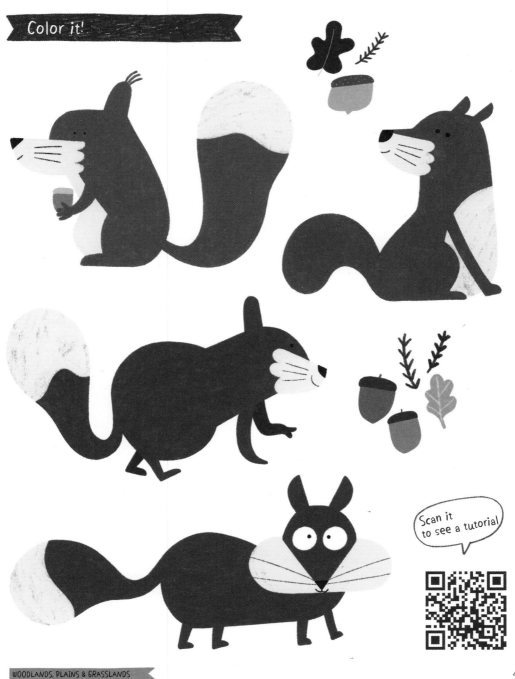

Color it!

Scan it to see a tutorial

KOALA

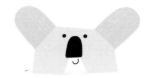

1 Draw a trapezoid for the head.

2 Draw two half-circles on each side of the head for the ears.

3 Below the head, draw a rectangle for the body.

4 Draw an arch on the body for the belly and legs.

5 Draw two arms and two hands.

6 Draw half an oval and a triangle for the nose and mouth. Add two feet.

7 Draw the eyes and mouth.

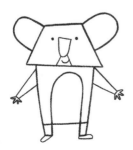

8 Round the corners of the face.

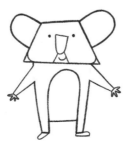

9 Remove all overlapping pencil lines.

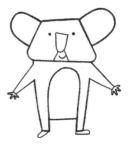

Drawing Class: Animals

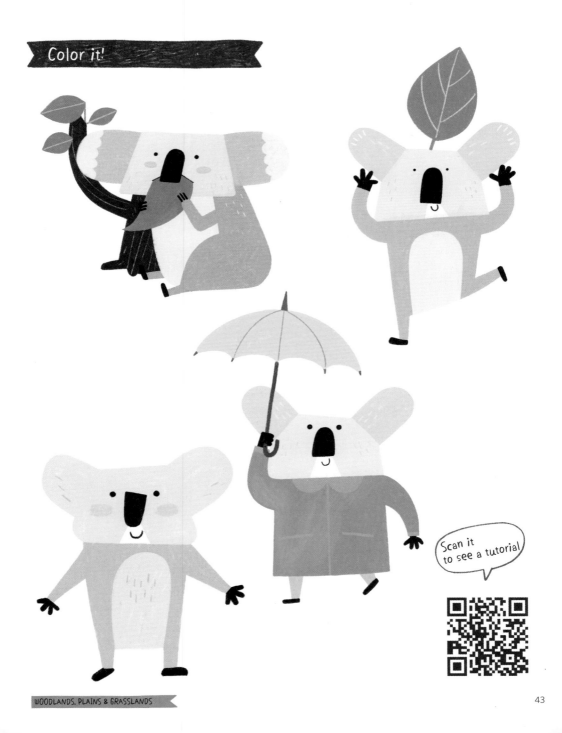

Color it!

Scan it to see a tutorial

MOOSE

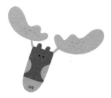

1 Draw an uneven rectangle for the head.

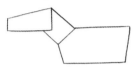

2 Draw a smaller rectangle on one side for the neck with a large rectangle attached for the body.

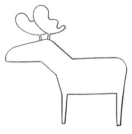

3 Round the shapes of the head and body and then draw two long rectangles for the legs.

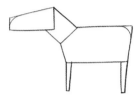

4 Remove all overlapping pencil lines.

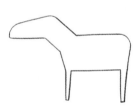

5 Draw two big antlers.

6 Draw an elongated half-circle for an ear, a nostril, two eyes, a mouth, and a line for the muzzle.

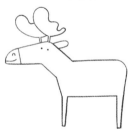

7 Draw a little beard and add a stubby tail. Add details to the hooves.

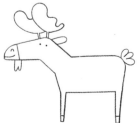

8 Draw the other two legs and hooves.

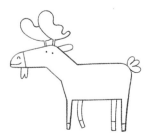

Drawing Class: Animals

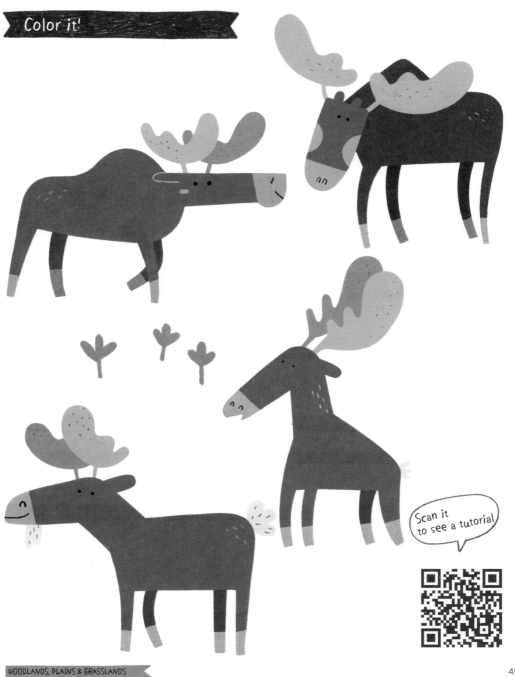

Color it!

Scan it
to see a tutorial

BISON

❶ Draw two rectangles on top of each other. The top one is for the head and the bottom is for the face.

❷ Draw a big circle behind the head and face for the shoulders.

❸ Draw the hindquarters with one leg and hoof. Add the front legs and hooves.

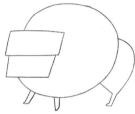

❹ Round the corners of the head and face. Add the horns on each side of the head and draw a scalloped line for the fur. Draw a tail.

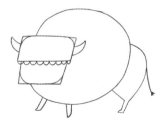

❺ Remove all overlapping pencil lines.

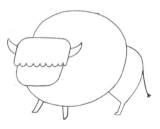

❻ Draw the eyes, nostrils, mouth, and other back leg and hoof. Add a beard under the chin and fur on the back of the legs.

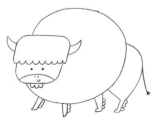

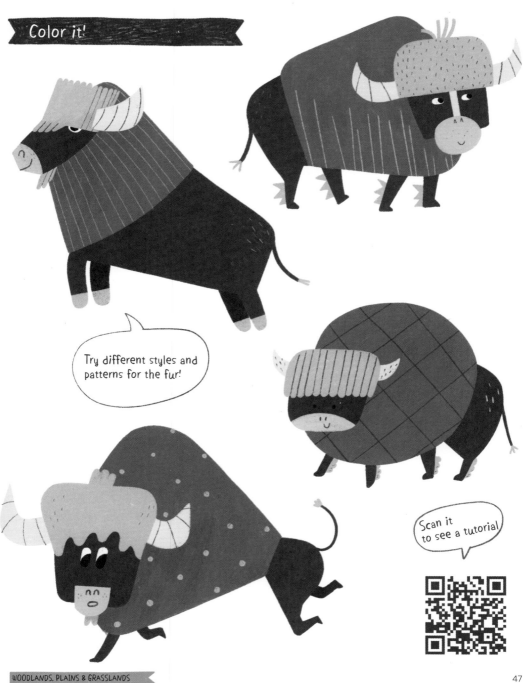

Color it!

Try different styles and patterns for the fur!

Scan it to see a tutorial

WOLF

1 Draw a trapezoid for the head.

2 Draw a narrow rectangle below it.

3 Draw a smaller upside-down trapezoid beneath the rectangle for the snout.

4 For the body, draw a rectangle on one side attached to the head.

5 Draw two triangles on top of the head for the ears and one front leg and one hind leg.

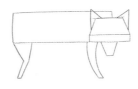

6 Inside the body shape, draw two bended parallel lines for the curved body and then draw a tail as an extension of the top body line. Draw the other front and hind legs.

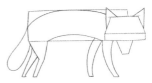

7 Inside the head, draw details for the face.

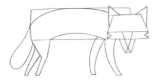

8 Remove all overlapping pencil lines.

9 Draw the eyes, eyebrows, and fur on the legs. Fill in the nose with black.

Drawing Class: Animals

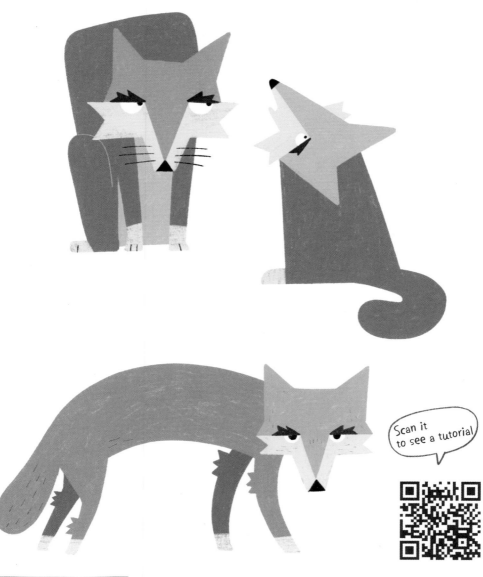

Scan it
to see a tutorial

ELEPHANT SHREW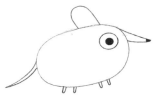

1 Draw an oval for the body.

2 Draw an elongated half-circle for the ear and a long pointy triangle for the snout. Draw four more small elongated half-circles for the legs.

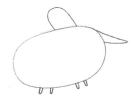

3 Draw a large eye, a small nose, and a thin tail.

4 Remove all overlapping pencil lines and add detail on the ear.

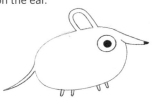

5 Draw a vertical line across the body and add whiskers.

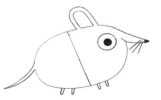

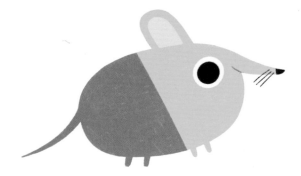

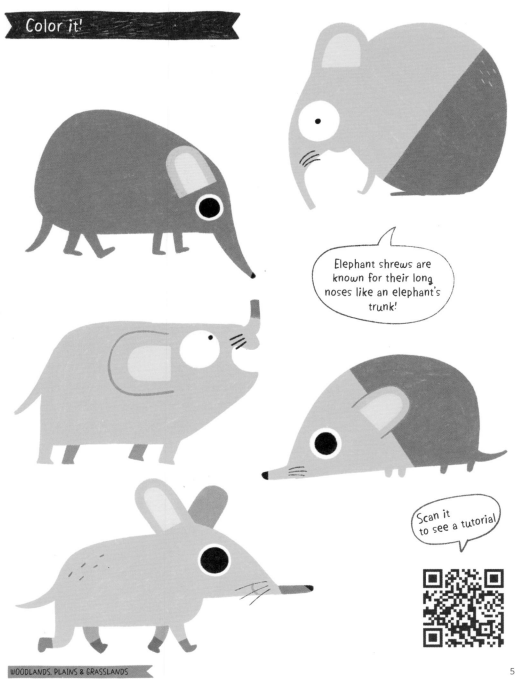

Elephant shrews are known for their long noses like an elephant's trunk!

Scan it to see a tutorial

YAK

1 Draw a square for the head.

2 Below that, draw a large rectangle for the body.

3 Draw a trapezoid on top of the head for hair. Draw four short legs and hooves.

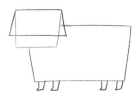

4 Draw horns on each side of the head. Round the head and hindquarters.

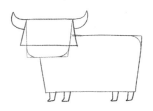

5 Remove all overlapping pencil lines. Draw a part in the hair. Draw straight lines for texture on the horns and add the nostrils.

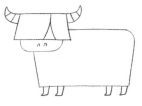

6 Draw vertical lines on the head and body for hair. Draw the tail and an eye showing through the part in the hair.

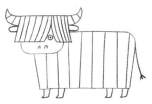

Drawing Class: Animals

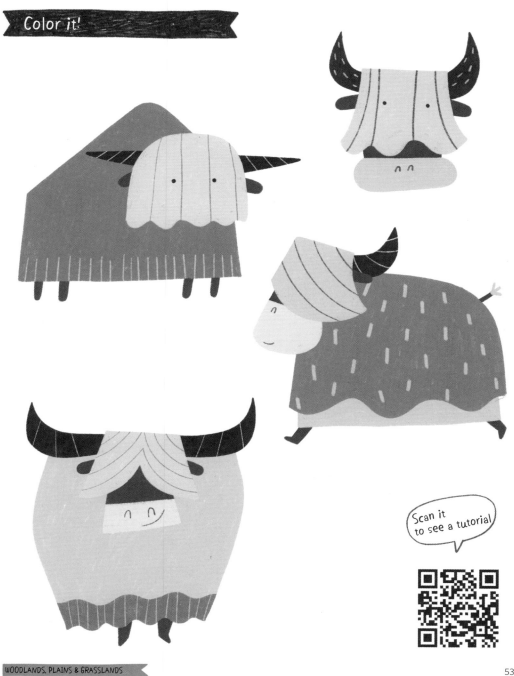

Color it!

Scan it
to see a tutorial

CRICKET

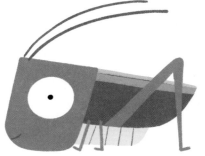

1 Draw a big rectangle for the body.

2 Add another longer rectangle on top of the body on one side for the head and draw a wider uneven rectangle next to the head for the wing.

3 Remove all overlapping pencil lines.

4 Round the bottom corner of the head. Draw a large eye and a hind leg.

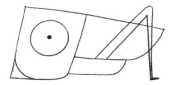

5 Draw the mouth, long feelers on top of the head, and front and mid legs.

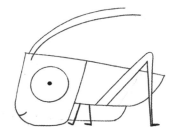

6 Add horizontal lines on the wing and vertical lines on the stomach for texture.

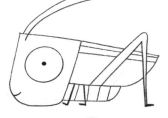

Scan it to see a tutorial

LADYBUG

1 Draw a big oval for the body.

2 Inside the oval, draw four straight lines like slicing a pie.

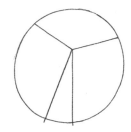

3 Draw the feelers on top of the head and two wings.

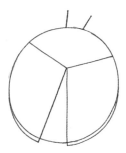

4 Remove all overlapping pencil lines. Draw circles for the black spots on the wings.

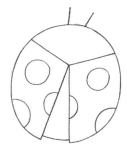

Drawing Class: Animals

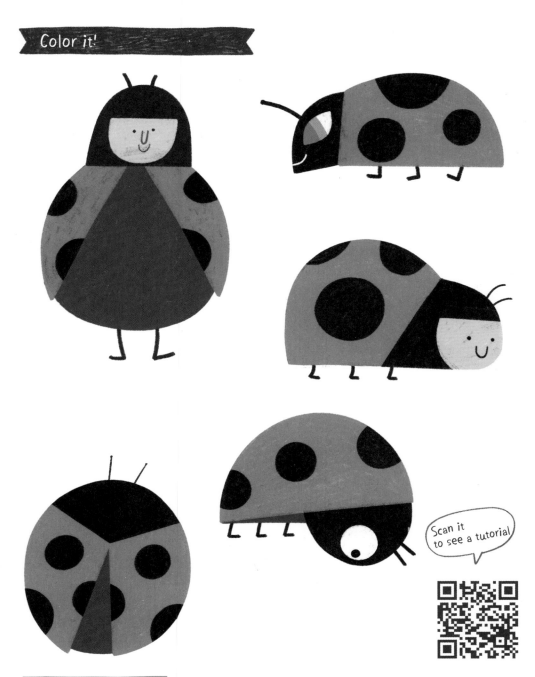

Color it!

Scan it to see a tutorial

MOTH

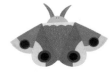

① Draw an upside-down triangle for the body.

② Draw a fan shape on each side of the body for the wings.

③ Draw two more fan shapes alongside.

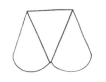

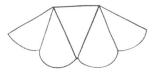

④ Draw a small half-circle on top of the body for the head. Draw patterns on the wings.

⑤ Draw large feelers on top of the head and two eyes. Add a scalloped pattern across the top of the body.

⑥ Add small details on the feelers.

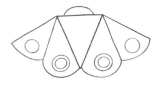

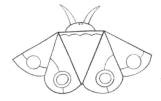

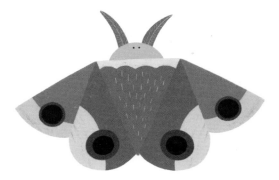

Drawing Class: Animals

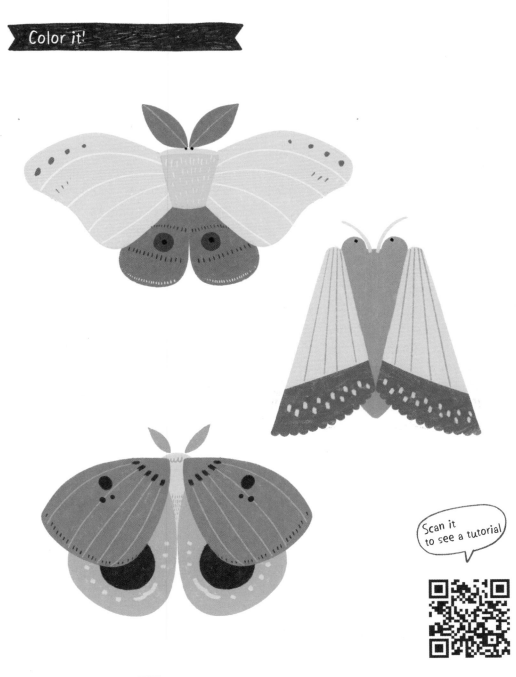

Scan it
to see a tutorial

DRAGONFLY

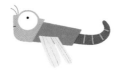

1 Draw a rectangle for the head.

2 Below that, add another long rectangle for the upper part of the body, the thorax.

3 Draw two circles on the head for the eyes. Add the elongated abdomen below the body. Round the corners of the head.

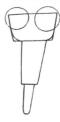

4 Draw two pairs of wings.

5 Remove all overlapping pencil lines.

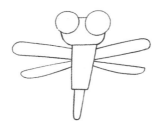

6 Draw the pupils, mouth, and the feelers on the top of the head. Add horizontal lines on the wings and abdomen for texture.

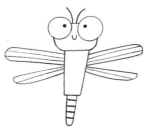

Drawing Class: Animals

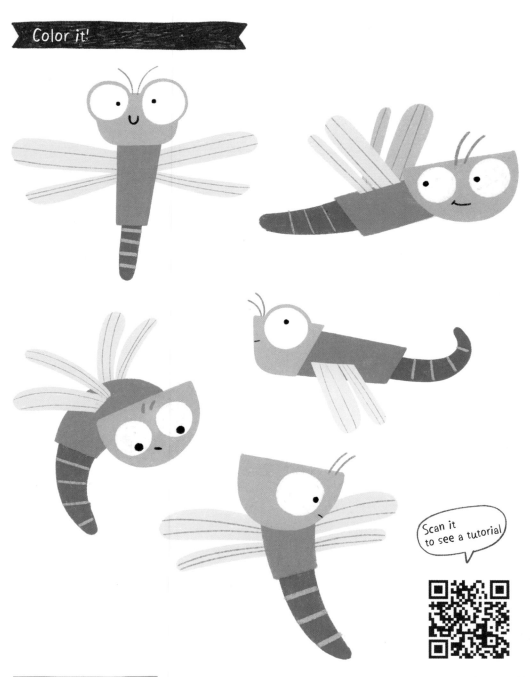

Color it!

Scan it
to see a tutorial

BEETLE

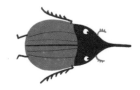

1 Draw a square for the head.

2 For the body, add a rectangle next to the head.

3 Draw two large horns, one on the top of the head and one on the bottom.

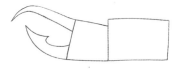

4 Round the corners of the body and draw a wavy line to divide the shell.

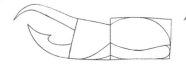

5 Connect the two horns with a smooth curved line. Draw a large eye.

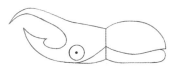

6 Remove all overlapping pencil lines.

7 Draw vertical lines on the belly and add three legs.

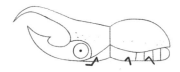

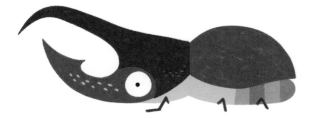

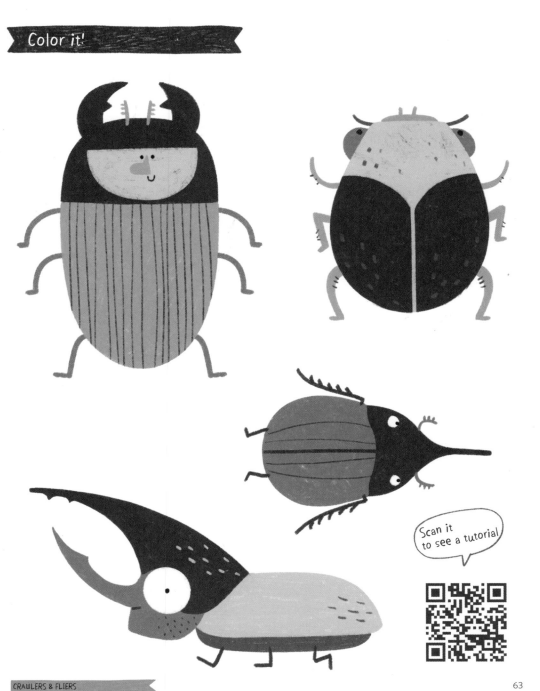

Color it!

Scan it to see a tutorial

WOODPECKER

① Draw two parallel lines for the trunk of a tree.

② Draw an uneven rectangle for the body close to the tree trunk.

③ On top of the body, draw two short lines for the neck.

④ Draw a rectangle for the head and a long pointy beak.

⑤ Add a half-circle over the body, letting the corner stick out of the bottom for the tail. Round the corner of the head and the body.

⑥ Remove all overlapping pencil lines. Draw a large eye and the cap of feathers on the head.

⑦ Draw a wing inside of the body and two stick legs and feet.

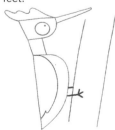

⑧ Draw feathers on the chest and add details to the tree.

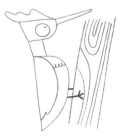

Drawing Class: Animals

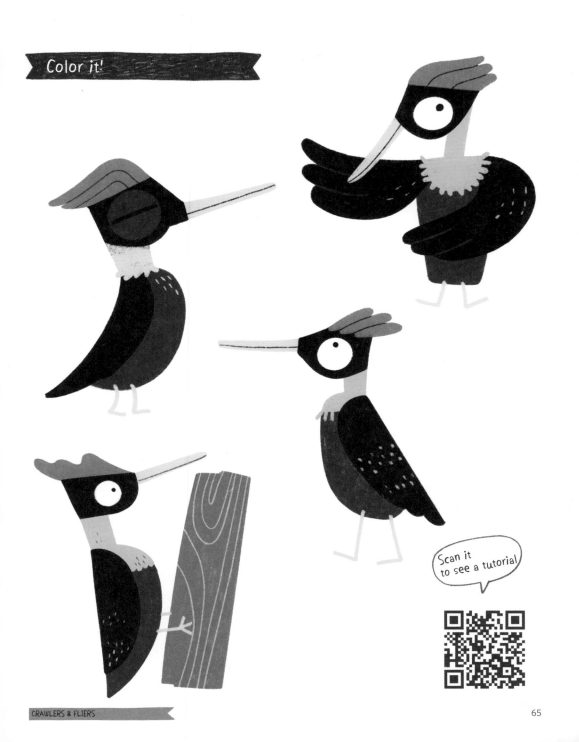

Color it!

Scan it
to see a tutorial

QUAIL

1. Draw a circle for the head.

2. For the body, draw a large rectangle, adjusting the lines to connect it to the head.

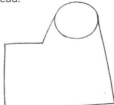

3. Round the corners of the body.

4. Remove all overlapping pencil lines.

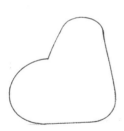

5. Draw an eye and a beak. Add an angled line to divide the head and body.

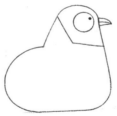

6. Draw a pointed wing and add feathers to the chest. Add two stick legs and feet.

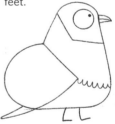

7. Draw feathers and a long plume at the top of the head.

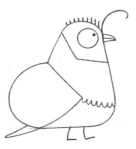

8. Add straight lines to the wing for the feathers and speckles on the body to create texture.

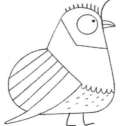

Drawing Class: Animals

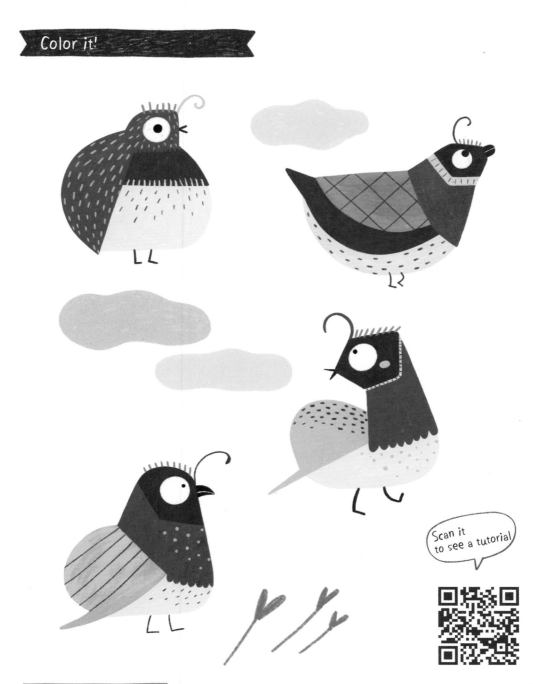

Scan it
to see a tutorial

CROW

❶ Draw a small square for the head. For the body, draw a large rectangle next to the head.

❷ Round the top of the head and the bottom of the body. Then, draw a smooth curved line connecting the two.

Draw an elongated small letter *m* shape for the tail.

❸ Remove all overlapping pencil lines.

❹ Draw an open beak, a large eye, and two stick legs and feet.

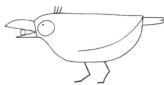

❺ Remove all overlapping pencil lines. Draw some feathers on top of the head, a wing, and an accessory between the beak, like a berry.

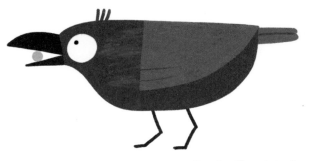

Drawing Class: Animals

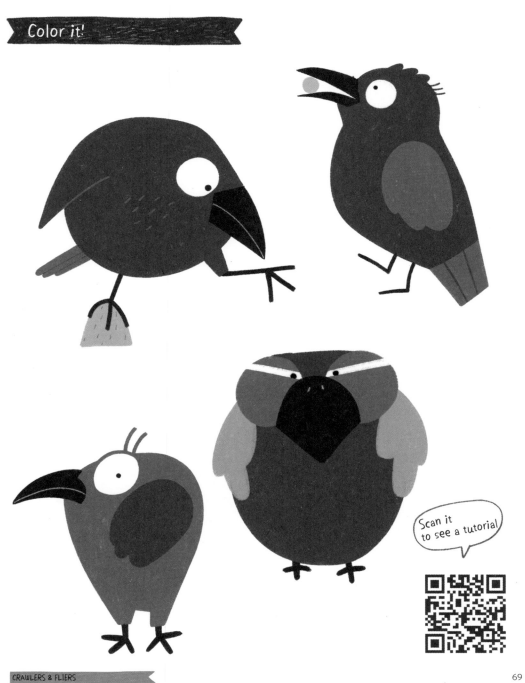

Scan it to see a tutorial

RED LORY

① Draw a rectangle for the body.

② For the head, draw a kite shape on one side, overlapping the body.

③ Round the corners of the body.

④ Remove all overlapping pencil lines.

⑤ Draw a beak, a large eye, and add two elongated half-circles for the thighs.

⑥ Draw the legs and feet. Add a pointy tail.

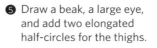

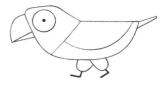

⑦ Draw straight lines on the wing for the feathers and add a nostril.

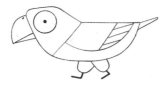

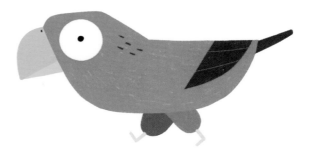

Scan it
to see a tutorial

HUMMINGBIRD

1 Draw a small circle for the head.

2 For the body, draw a wide half-circle attached to the head. Add a pointy tail.

3 Draw small letter *m* shapes for the two wings.

4 Remove all overlapping pencil lines.

5 Draw a needle-like a beak and an eye.

6 Draw a horizontal line to across the body from beak to tail.

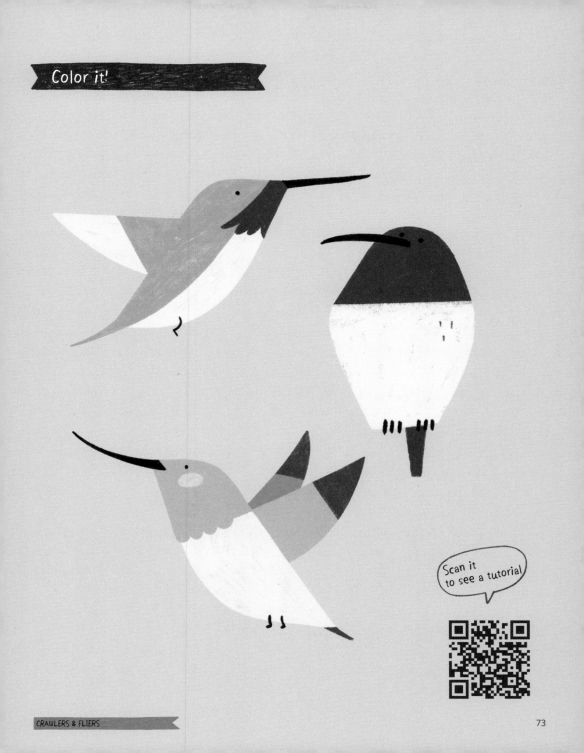

Color it!

Scan it to see a tutorial

EAGLE

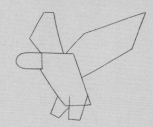

1 Draw a small elongated half-circle for the head.
For the body, draw an uneven rectangle, adjusting the lines to connect it to the head.

2 Draw two rectangles on the bottom of the body for the thighs.

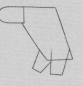

3 Draw two pentagon shapes for the wings.

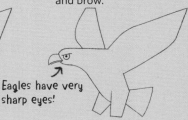

4 Draw a small crescent shape for the beak and a trapezoid for the tail.

5 Round the corners of the body and wings.

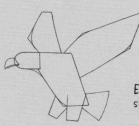

6 Remove all overlapping pencil lines. Draw an eye and brow.

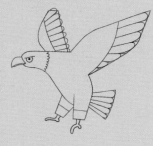

Eagles have very sharp eyes!

7 Draw horizontal lines on the wings and tail for the feathers and add a circle of feathers around the neck. Add the lower legs and talons and round the back.

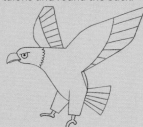

8 Draw scalloped edges on the tips of the feathers on the wings and tail.

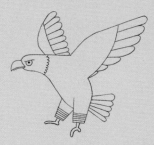

9 Remove all overlapping pencil lines. Add some horizontal lines on the legs for texture.

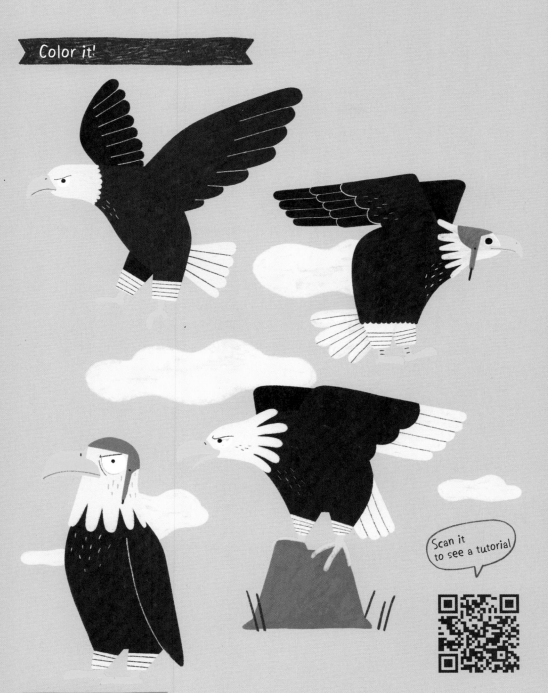

Color it!

Scan it
to see a tutorial

XENOPS

① Draw a circle for the head.

② Below that, draw a trapezoid for the body.

③ Draw a triangle on one side of the head. Round the front of the body.

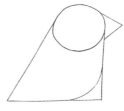

④ Draw a small elongated half-circle on the point of the triangle for the beak. Draw two stick legs and feet.

⑤ Remove all overlapping pencil lines.

⑥ Draw the mark around the eye and an eye. Add the tip of the tail.

⑦ Add a wing and a horizontal line across the beak.

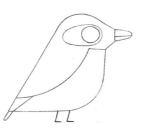

⑧ Draw straight lines on the wing for the feathers and other details and fill in the eye with black.

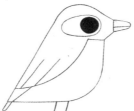

Drawing Class: Animals

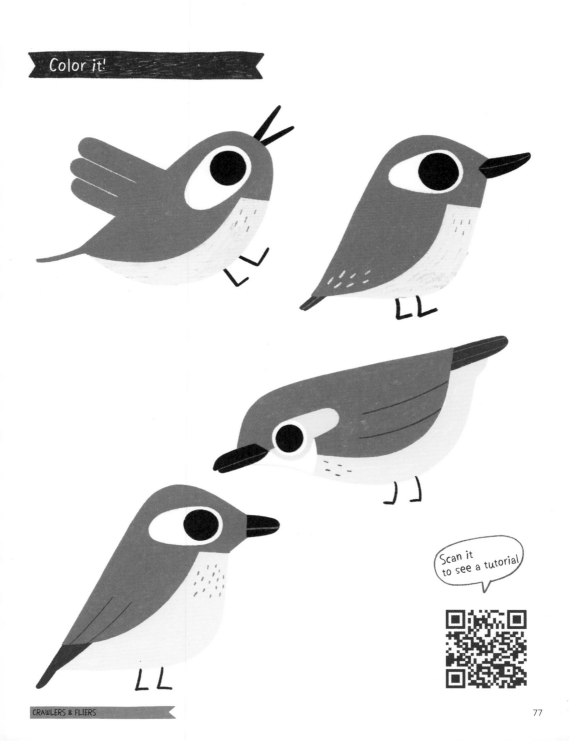

ALBATROSS

1 Draw a small circle for the head.

2 Below that, draw an oval for the body.

3 Connect the head and the body with two parallel straight lines. Draw two half-circles for the thighs and an elongated half-circle for the beak.

4 Draw a wide half-circle on the body for the wing and add stick legs and feet.

5 Remove all overlapping pencil lines.

6 Add details on the beak and a line on the wing. Draw the eye.

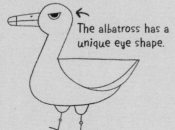

The albatross has a unique eye shape.

7 Draw the feathers on the wing.

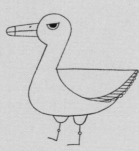

8 Remove all overlapping pencil lines.

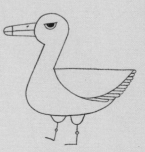

Drawing Class: Animals

Color it!

Different eye shapes can determine the character's personality.

Scan it to see a tutorial

BAT

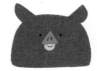

1. Draw a hexagon for the head.

2. Below that, draw a square for the body.

3. Add two large, curved wings, one on each side of the body.

4. Draw two half-circles attached to each side of the head for the ears and two small legs.

5. Add the eyes, nose, mouth, and fangs. Add details to the ears.

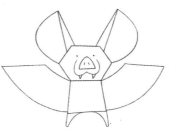

6. Add some fur on the chest and add vertical lines on the wings.

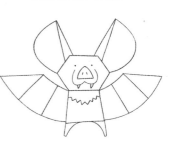

7. Draw more details on the wings.

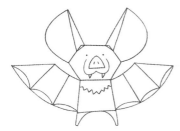

8. Add the feet.

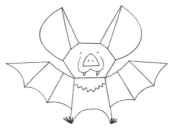

Drawing Class: Animals

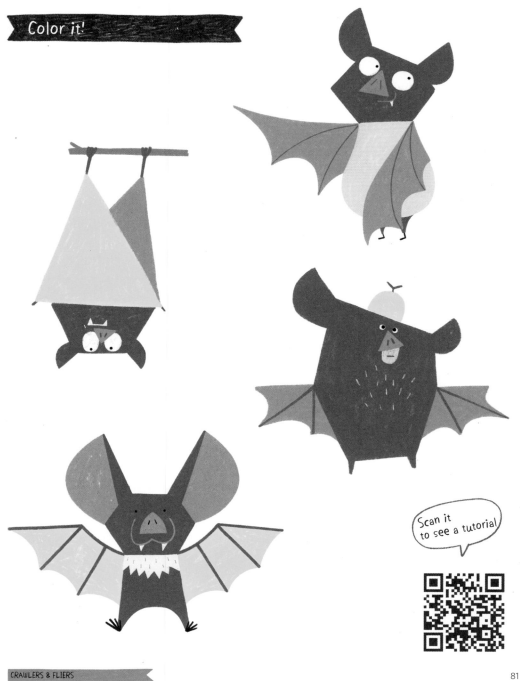

Scan it to see a tutorial

IGUANA

1 Draw a long trapezoid for the body.

2 Draw two rectangles on one side for the head.

3 Add a long triangle on the other side for the tail.

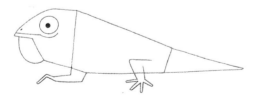

4 Add a half-circle under his chin for the dewlap. Remove the pencil line on the face.

5 Draw a front leg and back leg with claws and add a large eye, nostril, and mouth.

6 Draw vertical lines on the body, a dot on his face for an ear, and a line for the ridge over his eye.

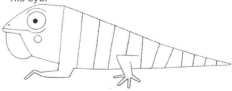

7 Draw the soft spines on his back and add vertical lines to the dewlap for detail.

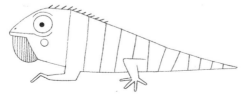

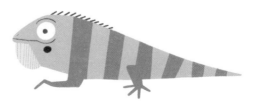

Drawing Class: Animals

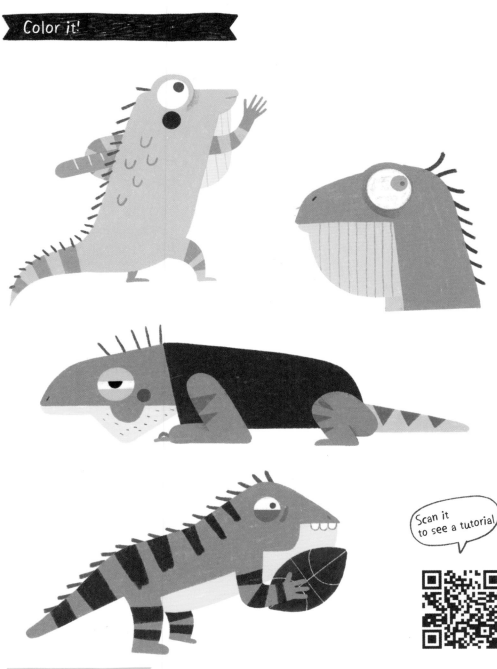

Scan it
to see a tutorial

TIGER

❶ Draw a half-circle for the head.

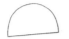

❷ Draw a smaller half-circle inside of the head. Add two small half-circles on top of the head for the ears.

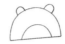

❸ Draw the outline of the nose and eyes.

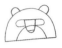

❹ Draw a long rectangle for the body and three small rectangles for the two back legs and one front leg.

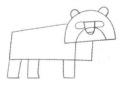

❺ Round the corners of the body.

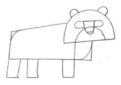

❻ Remove all overlapping pencil lines.

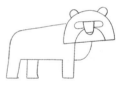

❼ Draw a tail and add the other raised front leg.

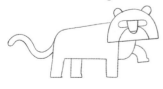

❽ Draw the pupils, mouth, and whiskers. Add fur on each side of the head. Fill in the nose with black. Add detail to the ears and head.

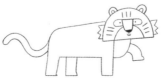

❾ Draw stripes on the body, legs, and tail.

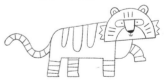

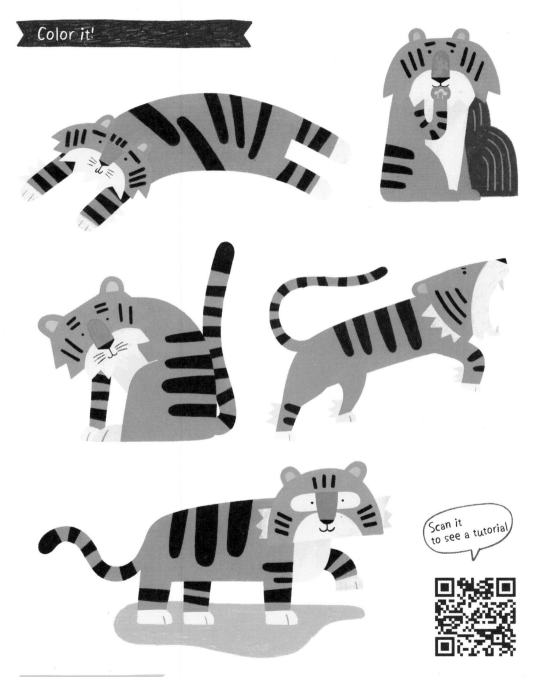

Color it!

Scan it
to see a tutorial

MONKEY

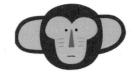

① Draw a circle for the head.

② For the body, draw a rectangle attached to the head.

③ Add two big half-circles on each side of the head for the ears and add one leg with a foot and one arm with a hand.

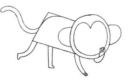

④ Draw a heart shaped line inside the head for the face and add the other leg and foot.

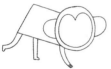

⑤ Round the hindquarters. Draw a long tail and the other arm and hand.

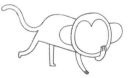

⑥ Remove all overlapping pencil lines.

⑦ Draw the eyes, nostrils, and mouth. Add detail to the ears.

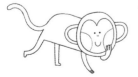

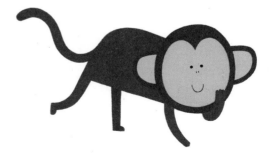

Color it!

Scan it to see a tutorial

CAPYBARA

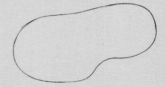

1 Draw two uneven circles side by side, making the lower one for the body slightly larger.

2 Connect the head and body with two curving lines.

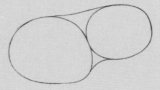

3 Remove the pencil lines inside where the head and body attach.

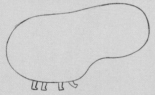

4 Draw four short little legs with feet.

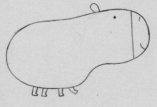

5 Add a vertical line for the muzzle, a nostril, a mouth, an elongated half-circle for an ear, and a dot for the eye.

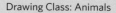

Drawing Class: Animals

Scan it
to see a tutorial

JAGUAR

1 Draw a wide rectangle for the body.

2 Draw a smaller rectangle on the bottom on one side for the head and add a trapezoid beneath it for the snout.

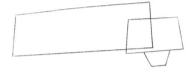

3 Draw two front legs and one back leg with paws.

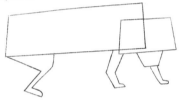

4 Draw two half-circles on top of the head for the ears, a long tail, and the other back leg and paw.

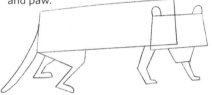

5 Round all the corners.

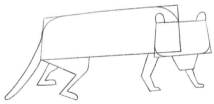

6 Remove all overlapping pencil lines.

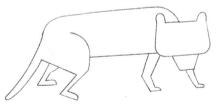

7 Draw the eyes, nose, and mouth. Add spots all over and details to the ears.

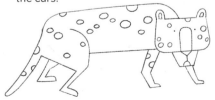

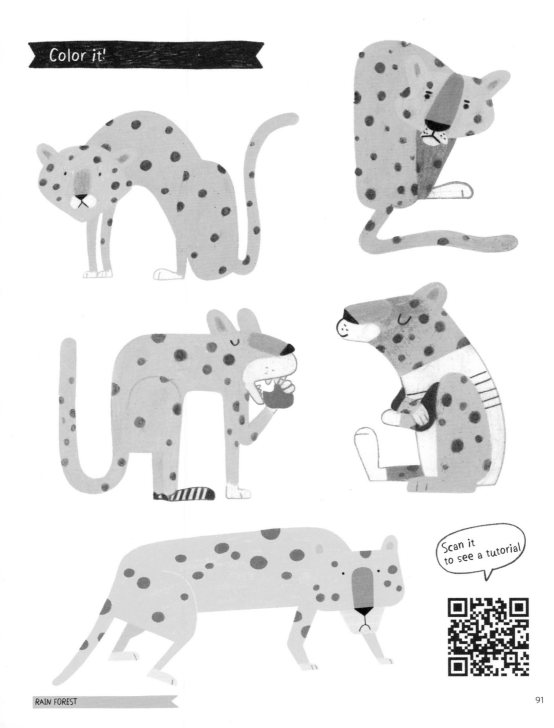

Color it!

Scan it
to see a tutorial

SLOTH

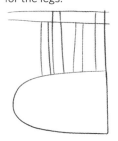

1 Draw half an oval with one flat side for the head and body.

2 Above that, draw two parallel lines for a branch.

3 Add four long rectangles for the legs.

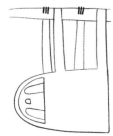

4 Draw a half-circle inside on the curved side of the head.

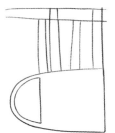

5 Draw outlines for the eyes and nose.

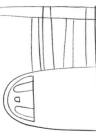

6 Remove all overlapping pencil lines. Draw three claws each for two of the paws wrapped around the branch.

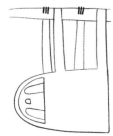

7 Add shading in the outlines around the eyes and add the pupils. Fill in the nose with black.

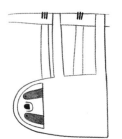

8 Draw a leaf on the branch.

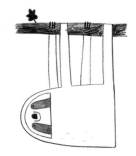

Drawing Class: Animals

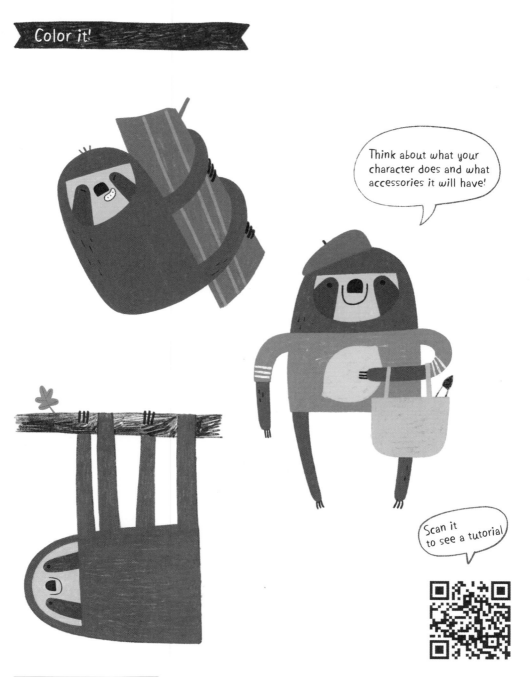

Think about what your character does and what accessories it will have!

Scan it to see a tutorial

ORANGUTAN

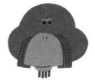

1 Draw a rectangle for the head and divide it into two, making the top rectangle smaller than the bottom.

2 Inside of the top rectangle, draw a half-circle. In the bottom rectangle, draw an oval.

3 Draw a half-circle on the bottom of the oval for the mouth and a smaller one below it for the jaw.

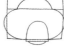

4 Remove all overlapping pencil lines.

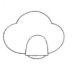

5 Draw the hair, ears, eyes, brows, and nostrils.

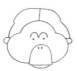

6 Draw the arms and hands.

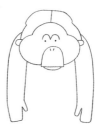

7 Draw the legs and feet and lower body.

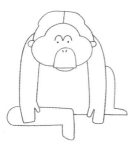

8 Draw hair around the mouth. Add short lines for the fingers and toes.

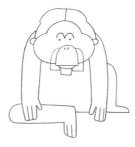

9 Add some texture to the hair around the mouth and on top of the head, ears, arms, and body.

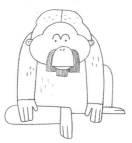

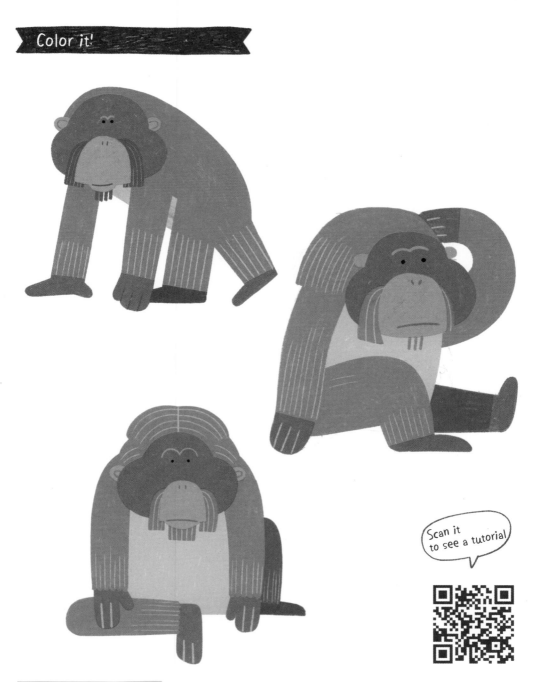

Scan it
to see a tutorial!

ALLIGATOR

1 Draw a rectangle for the body.

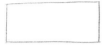

2 Add two long, narrow rectangles at one end for the head, making the top one longer.

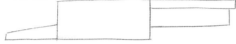

3 Draw two half-circles along the top edge of the longer rectangle where it meets the body for the eyes. To the other side of the body, add a long triangle in the bottom corner for the tail.

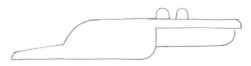

4 Round all the corners.

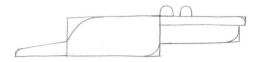

5 Remove all overlapping pencil lines.

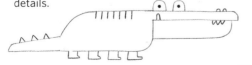

6 Draw four short legs with feet and spikes along the top edge of the tail.

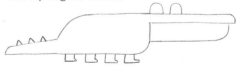

7 Add the nostrils, teeth, pupils, short vertical lines across the back, and other details.

Drawing Class: Animals

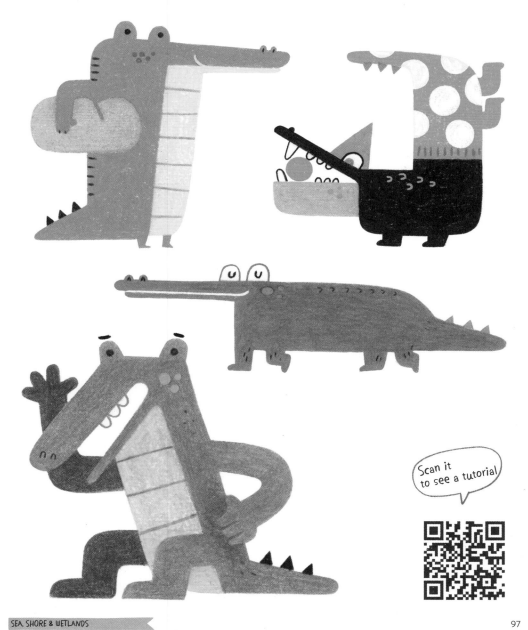

Scan it
to see a tutorial

BEAVER

1 Draw a square for the head. For the body, draw an uneven rectangle, adjusting the lines to connect it to the head.

2 Round the corners of the head and body.

3 Remove all overlapping pencil lines.

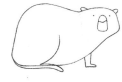

4 Draw two half-circles for the ears. Draw the eyes, nose, and the outline of the snout. Add a back leg and foot and one front leg and paw.

5 Add the details of the mouth, the other front leg and paw, and a crescent shape for the tail.

6 Remove all overlapping pencil lines.

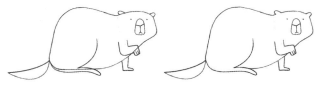

7 Add a crisscross pattern on the tail for texture, a branch in his front paw, and whiskers. Fill in his nose with black and add detail to the ears and paws.

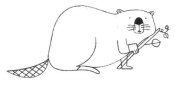

8 Fill in his back foot and paws with black.

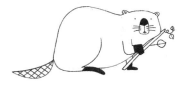

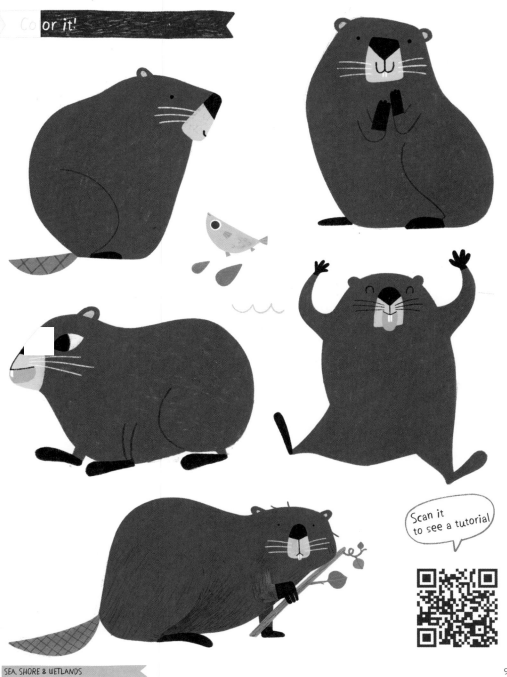

Scan it
to see a tutorial

FROG

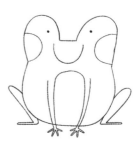

1 Draw an oddly shaped small letter *m*.

2 Close the shape by drawing the letter *U* below.

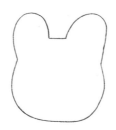

3 Draw the two rear legs and feet.

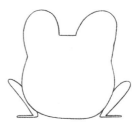

4 Draw the two front legs and feet.

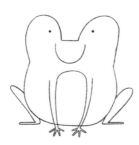

5 Draw the eyes, mouth, and stomach.

6 Draw the details on the cheeks.

Drawing Class: Animals

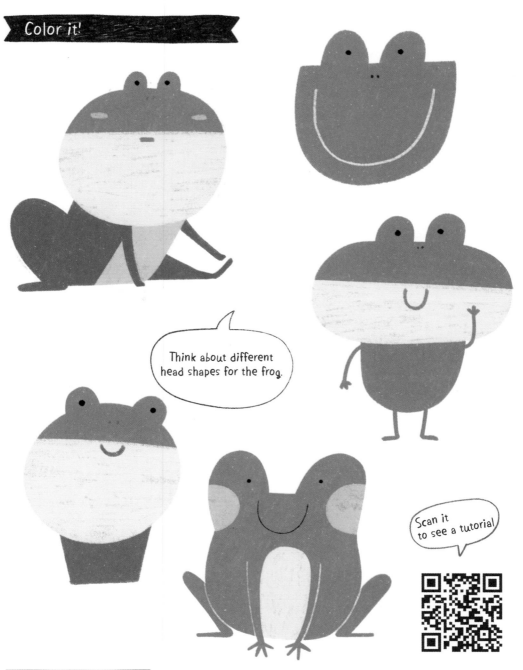

Think about different
head shapes for the frog.

Scan it
to see a tutorial

WALRUS

1 Draw a rectangle for the face.

2 Draw a trapezoid around the face for the head. For the body, add another rectangle, attaching it to the head.

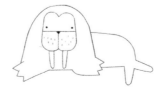

3 Draw the outline of the face and two hind flippers. Round the corners of the face.

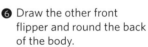

4 Round the top of the head and add one front flipper.

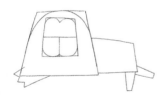

5 Remove all overlapping pencil lines.

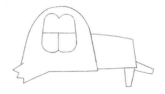

6 Draw the other front flipper and round the back of the body.

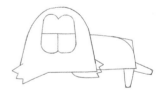

7 Remove all overlapping pencil lines.

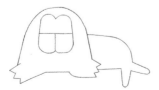

8 Draw the eyes, nose, and tusks and add whiskers.

Drawing Class: Animals

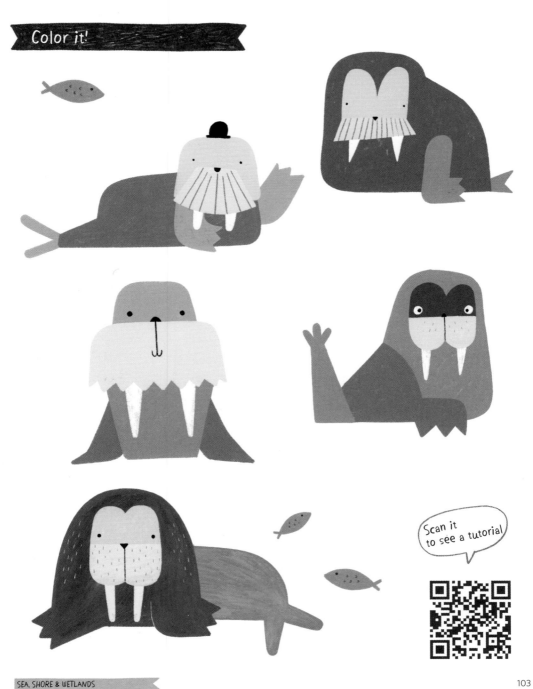

Color it!

Scan it
to see a tutorial

JELLYFISH

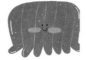

1 Draw a rectangle for the body.

2 Below that, draw a scalloped edge.

3 Round the corners of the body.

4 Remove all overlapping pencil lines.

5 Draw the long tentacles beneath.

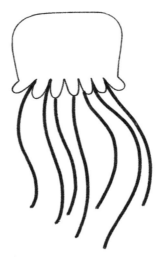

6 Draw two eyes, a mouth, the light reflecting off the body, and other details.

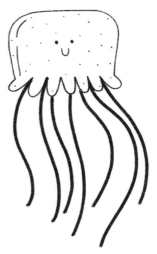

Drawing Class: Animals

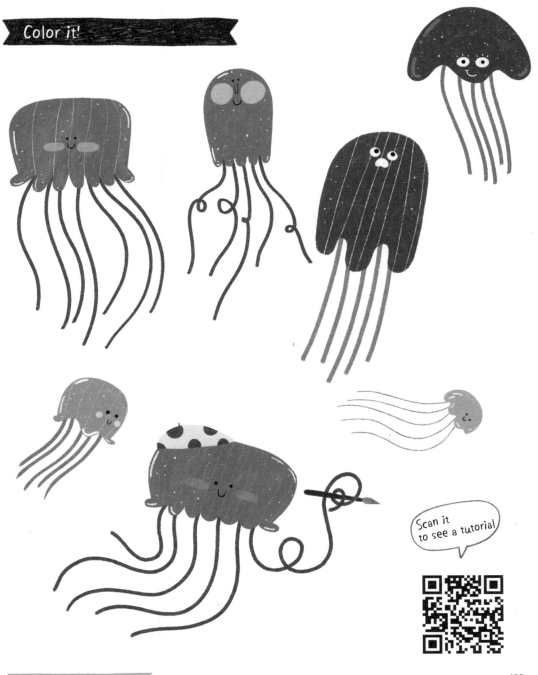

Color it!

Scan it to see a tutorial

LOBSTER

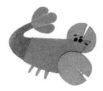

1 Draw an elongated half-circle for the head and body.

2 Below that, draw another elongated half-circle for the tail and then add the tail fan.

3 Draw a claw on one side using a short line, a small half-circle, and a large half circle.

4 Complete the claw by adding another slightly smaller half circle.

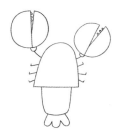

5 Draw the second claw in the same way.

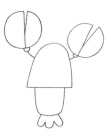

6 Draw six legs.

7 Draw the eyes and add some curved lines on the tail and details on the claws.

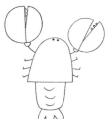

8 Draw the feelers on top of the head.

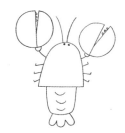

Drawing Class: Animals

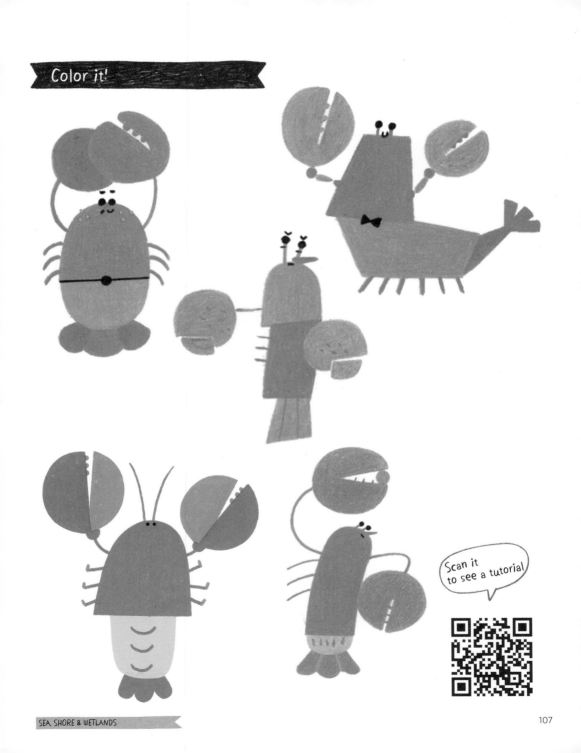

Color it!

Scan it
to see a tutorial

SHARK

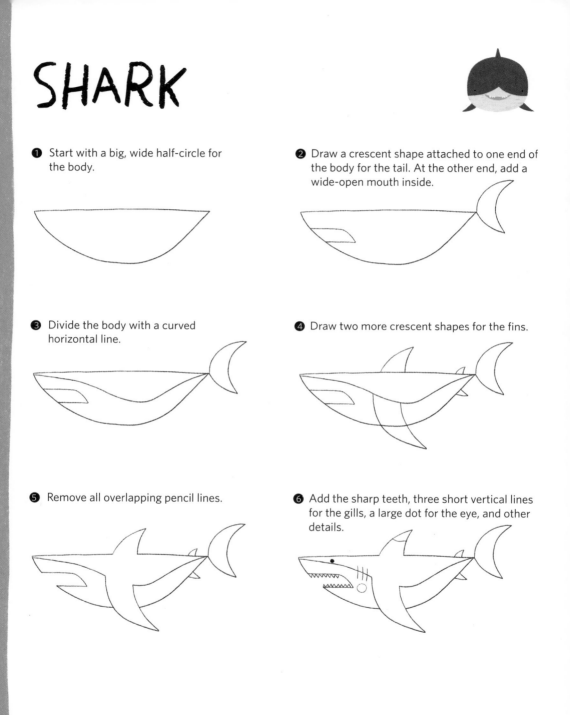

1 Start with a big, wide half-circle for the body.

2 Draw a crescent shape attached to one end of the body for the tail. At the other end, add a wide-open mouth inside.

3 Divide the body with a curved horizontal line.

4 Draw two more crescent shapes for the fins.

5 Remove all overlapping pencil lines.

6 Add the sharp teeth, three short vertical lines for the gills, a large dot for the eye, and other details.

Drawing Class: Animals

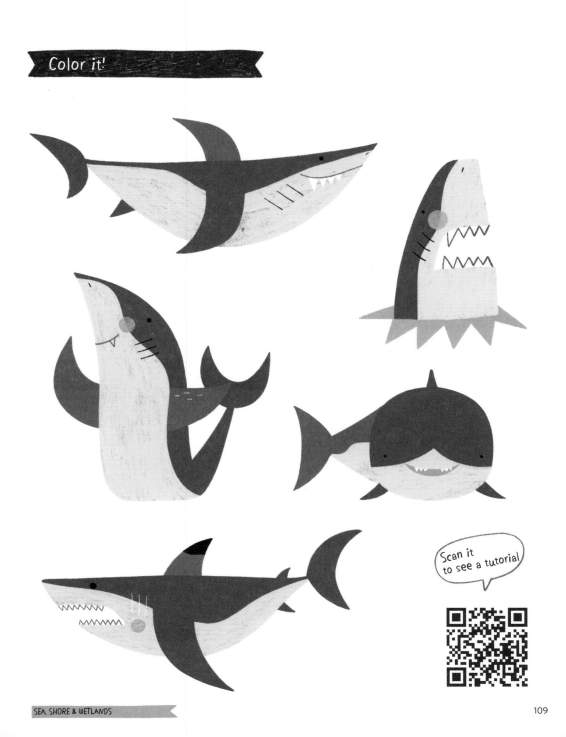

Scan it
to see a tutorial

SEA TURTLE

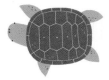

1 Draw a large half-circle with one flat side for the body.

2 Draw a smaller half-circle for the head.

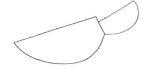

3 Draw another half-circle for the back leg and an upside-down teardrop for the front leg. Add a circle for the eye.

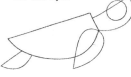

4 Remove all overlapping pencil lines.

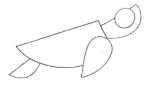

5 Draw a pupil, nostril, and a mouth. Start a pattern of overlapping shapes on the back of the shell and add a curving horizontal line to separate the top from the bottom.

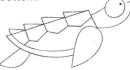

6 Complete the shell pattern and add vertical lines on the bottom.

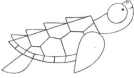

7 Draw some dots on the shell, legs, and neck. Remove overlapped pencil lines.

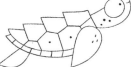

8 Draw larger dots on the top of the shell and add other details.

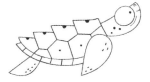

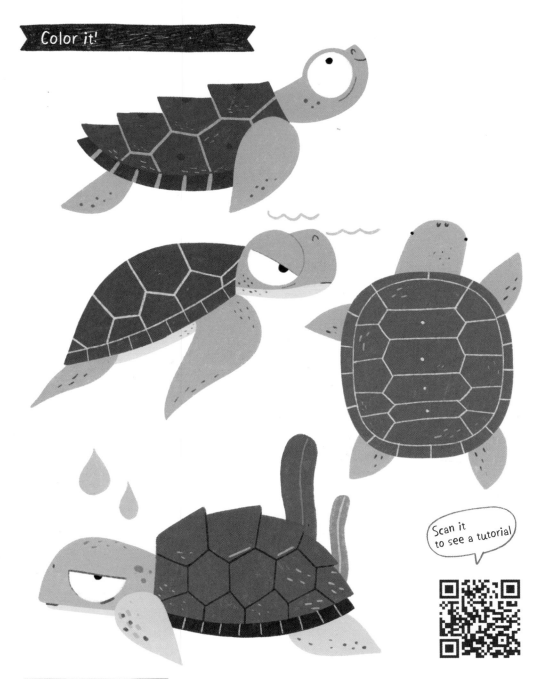

Color it!

Scan it
to see a tutorial

TROPICAL FISH

① Draw an oval for the body.

② Draw a mouth on one side and the tail fin on the other side.

③ Draw a line to divide the face and body. Draw a large eye.

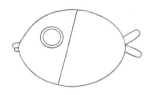

④ Add the top and bottom fins. Color in the pupil of the eye with black.

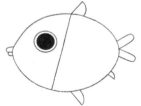

⑤ Draw half-circles for the scales and a line for the mouth.

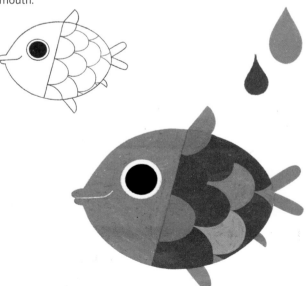

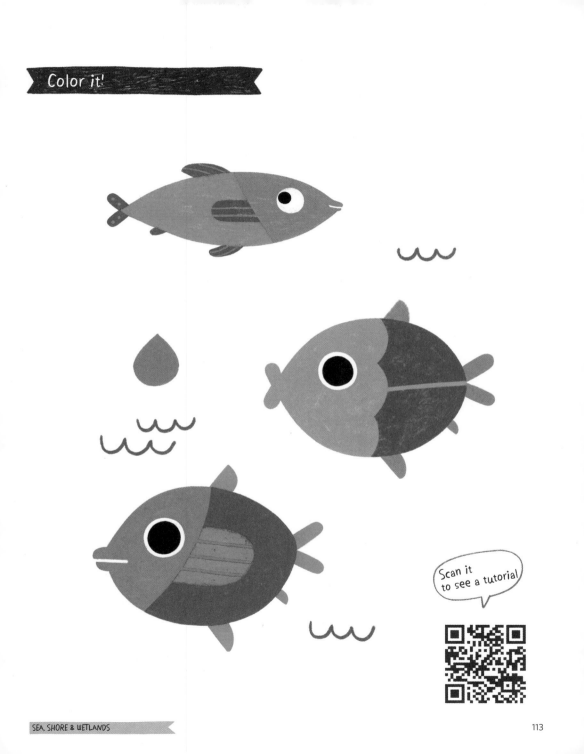

SEAHORSE

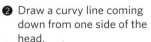

1 Draw a circle for the head.

2 Draw a curvy line coming down from one side of the head.

3 Draw another curvy line next to it to complete the shape for the body. Draw a pointy triangle on the head for the nose.

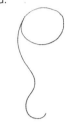

4 Draw a large eye, dorsal fin, and spines on the head.

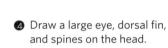

5 Remove all overlapping pencil lines.

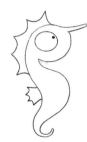

6 Draw a wavy vertical line on the body to separate the back and stomach. Draw straight lines for details on the fins and spines.

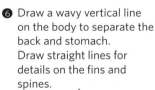

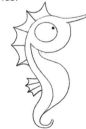

7 Add horizontal lines across the stomach.

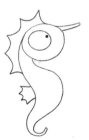

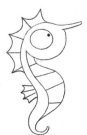

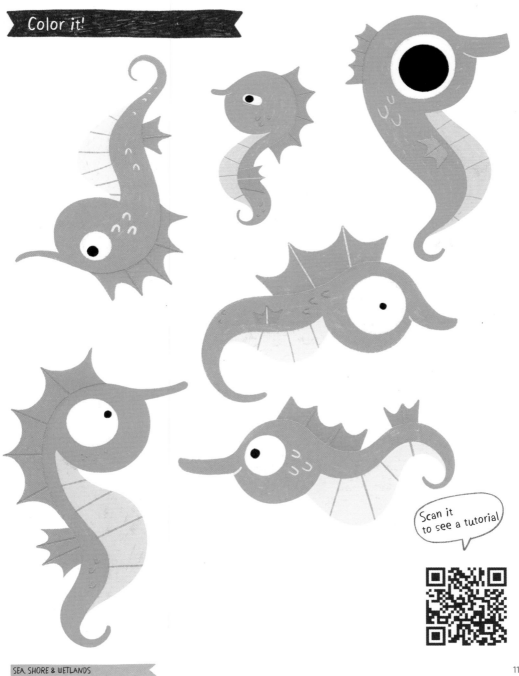

Scan it
to see a tutorial

SQUID

① Draw a small triangle for the fins.

② Below that, draw a longer triangle for the body.

③ Draw two circles on the bottom of the body for the eyes.

④ Remove all overlapping pencil lines.

⑤ Draw the large pupils, a mouth, and add thick curvy lines for the tentacles.

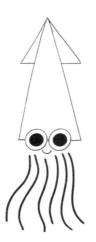

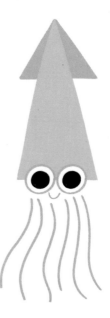

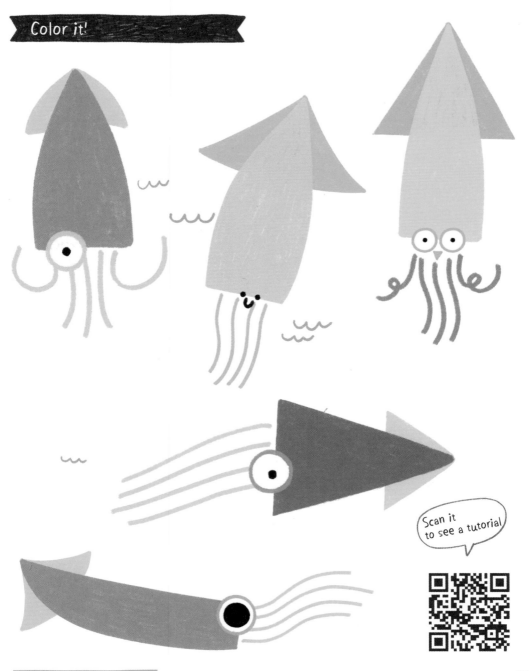

Color it!

Scan it to see a tutorial

X-RAY FISH

① Draw a wide half-circle for the head and body.

② Draw a straight vertical line at one end to divide the head from the body. Add the tail fins.

③ Draw a large eye and top and bottom fins.

④ Draw the bones visible inside the body. Add a mouth.

⑤ Fill in the pupil with black, add straight lines for texture on the fins, and draw a circle inside the body for the air bladder.

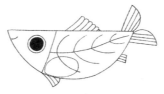

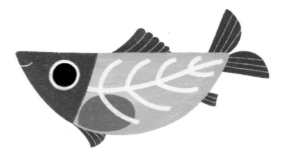

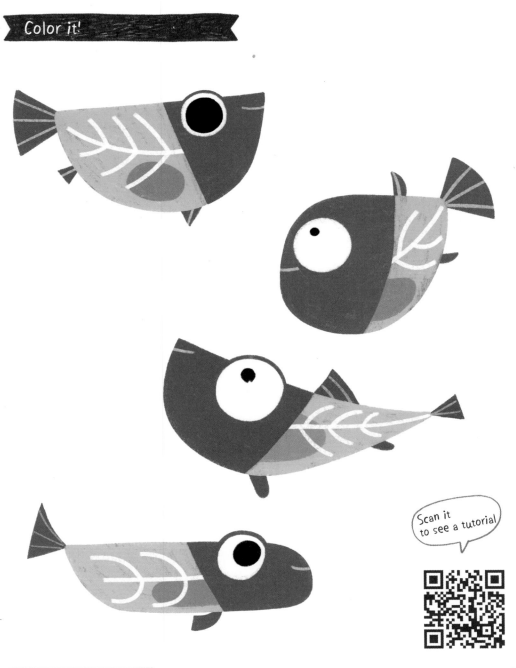

Color it!

Scan it
to see a tutorial

DINOSAUR

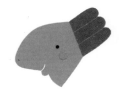

❶ Draw a large rectangle for the body.

❷ Draw a small rectangle for the head on one side of the body and a triangle for the tail on the other side.

❸ Round the corners of all the shapes.

❹ Remove all overlapping pencil lines.

❺ Draw four elongated half-circles for the legs.

❻ Draw more elongated half-circles for spikes along the back of the body and add two eyes and a mouth.

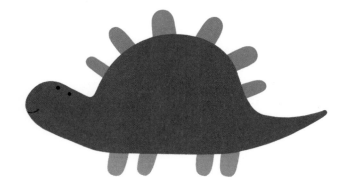

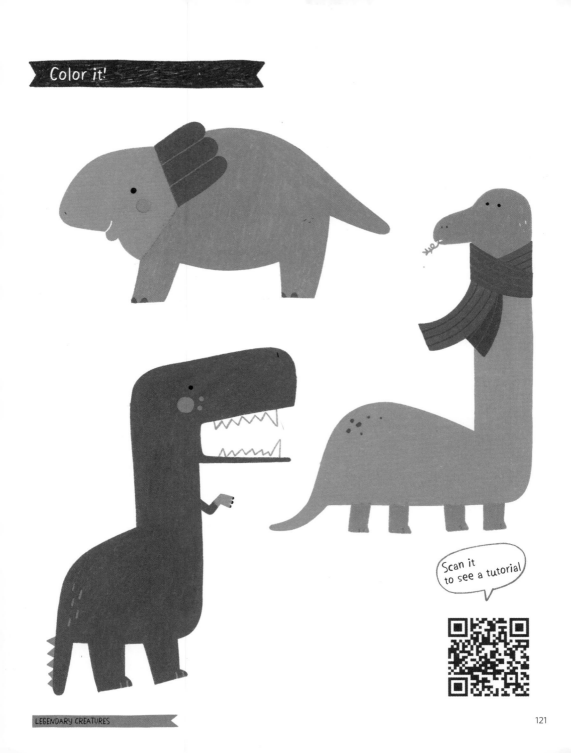

Color it!

Scan it
to see a tutorial

DODO

1 Draw a rectangle for the head.

2 Below that, add a long and narrow rectangle for the neck.

3 Draw another rectangle on the side of the head for the beak. For the body, draw a pentagon, attaching it to the neck.

4 Draw a curved line for the face connected to the beak and add a small triangle at the bottom of the beak. Draw two elongated half-circles under the body for the thighs.

5 Round the corners of the head and body.

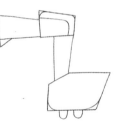

6 Remove all overlapping pencil lines.

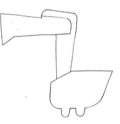

7 Round the front of the beak. Draw the two eyes and add a line for the mouth. Draw the legs and feet.

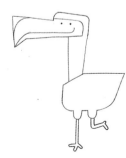

8 Draw the wing and add feathers around the neck.

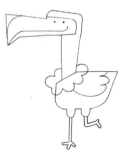

9 Remove all overlapping pencil lines. Add a tail and details to the beak.

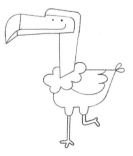

Drawing Class: Animals

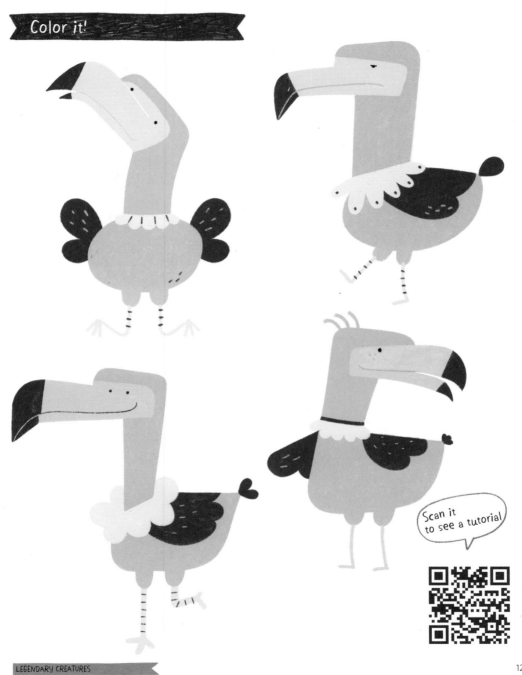

Scan it
to see a tutorial

UNICORN

● Draw a small rectangle for the head.

❷ Add a larger rectangle for the neck beneath it.

❸ Below that, draw another rectangle for the body.

❹ To the head, add a half-circle at one end for the muzzle and two elongated half-circles for the ears on the other end. Draw four small rectangles for the legs.

You can make the legs long or short!

❺ Add four half-circles on the neck for the mane.

❻ Remove all overlapping pencil lines.

Make the hindquarters round!

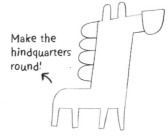

❼ Add a tail and a pointy triangle for the horn.

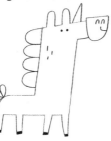

❽ Draw the eyes, nostrils, and mouth. Fill in the hooves with black and add other details.

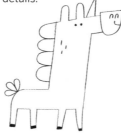

Drawing Class: Animals

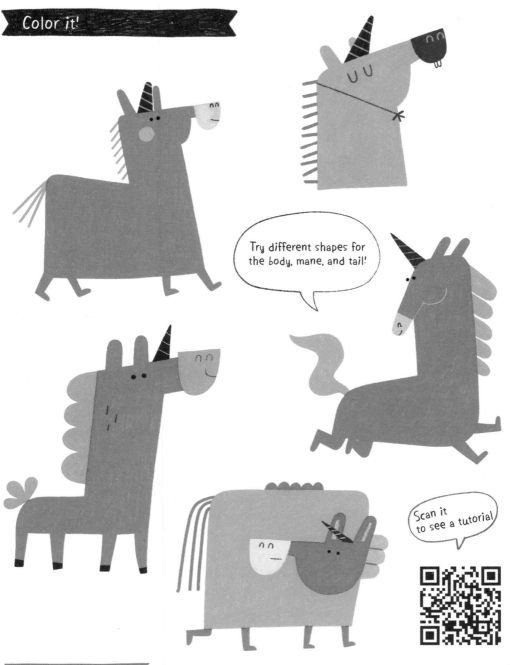

Try different shapes for the body, mane, and tail!

Scan it to see a tutorial

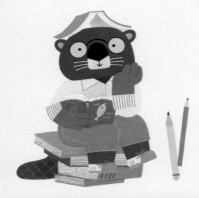

ABOUT THE AUTHOR

Heegyum Kim is an illustrator and designer. She holds a master of science in communication design from Pratt Institute and is the published author of two illustrated books featuring Mr. Fox, the charming and humorous character whose activities and musings drive her popular Instagram account and make her followers giggle, as do a menagerie of other delightful animal friends.

She is also the author and illustrator behind several titles published by Quarry Books, including the Draw 62 . . . and Make Them Cute series, which provides step-by-step illustrations for drawing different types of cute characters.

Heegyum also received honors recognition at the Society of Children's Book Writers and Illustrators (SCBWI) 2022 Winter Conference Portfolio Showcase.

She lives in Elmsford, New York. See more of Heegyum's work on her website (mrfox.nyc) and follow her drawing adventures on Instagram (@hee_cookingdiary) and Youtube (Heegyum Kim Illustration).

Inspiring | Educating | Creating | Entertaining

Brimming with creative inspiration, how-to projects, and useful information to enrich your everyday life, quarto.com is a favorite destination for those pursuing their interests and passions.

First Published in 2023 by Quarry Books, an imprint of The Quarto Group, 100 Cummings Center, Suite 265-D, Beverly, MA 01915, USA.
T (978) 282-9590 F (978) 283-2742 Quarto.com

Quarry Books titles are also available at discount for retail, wholesale, promotional, and bulk purchase. For details, contact the Special Sales Manager by email at specialsales@quarto.com or by mail at The Quarto Group, Attn: Special Sales Manager, 100 Cummings Center, Suite 265-D, Beverly, MA 01915, USA.

10 9 8 7 6 5 4 3 2 1

ISBN: 978-0-7603-7933-2

Digital edition published in 2023

eISBN: 978-0-7603-7934-9

Library of Congress Cataloging-in-Publication Data available

Design and Page Layout: Heegyum Kim
 Visit her website: www.mrfox.nyc
 Instagram: @hee_cookingdiary
 Youtube: HeegyumKimIllustration

Printed in China

**Draw 62 Animals
and Make Them Cute**

978-1-63159-675-9

**Draw 62 Magical Creatures
and Make Them Cute**

978-1-63159-682-7

**Draw 62 Characters
and Make Them Cute**

978-1-63159-821-0

**Draw 62 Things in Nature
and Make Them Cute**

978-1-63159-945-3